Black Hills

impressions

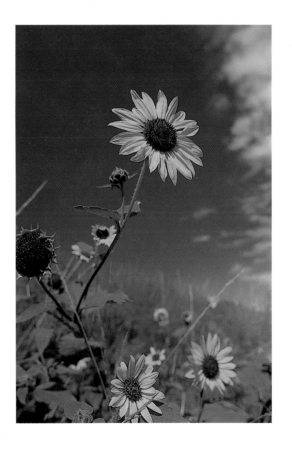

Photography and text
by Dick Kettlewell

FARCOUNTRY
PRESS

D1298361

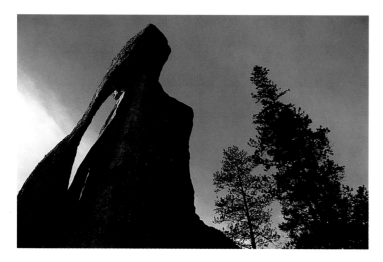

ABOVE: The Needles Eye, central Black Hills. The "eye" is the result of millions of years of wind erosion being brought to bear on a spire of solid granite.

TITLE PAGE: Maximilian sunflowers bask in the summer breeze on the prairies of Wind Cave National Park in the southern part of the Black Hills.

RIGHT: The carved faces of the Mount Rushmore National Memorial in the central Black Hills are among the most famous and most visited manmade landmarks in the world. Conceived and directed by sculptor Gutzon Borglum, the work began in 1927 and was completed in 1941.

FRONT COVER: A herd of bison grazes in Custer State Park.

BACK COVER: An antelope (or pronghorn) doe and fawn, Custer State Park.

ISBN 1-56037-289-3
© 2004 Farcountry Press
Photographs © Dick Kettlewell
Text by Dick Kettlewell

For more information on our books write Farcountry Press, P.O. Box 5630, Helena, MT 59604; call (800) 821-3874; or visit www.farcountrypress.com

Created, produced, and designed in the United States.

Printed in China.

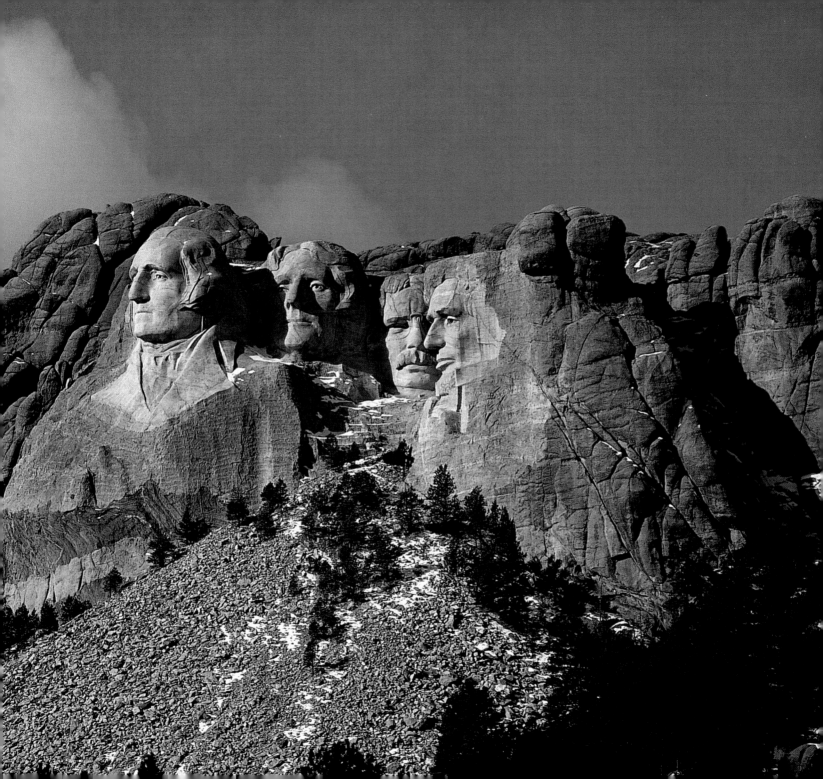

Introduction

by Dick Kettlewell

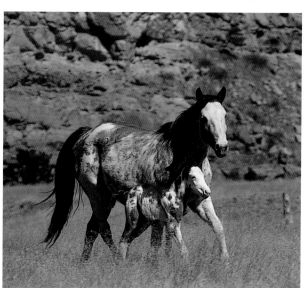

ABOVE: A wild mare and her shy foal graze at the Black Hills Wild Horse Sanctuary along the Cheyenne River in the southern Black Hills.

RIGHT: Isak Dinesen, in *Out of Africa*, described Africa's Ngong Hills as "a landscape with no fat on it and no luxuriance anywhere," and such could be said of the South Dakota Badlands as well.

Through tall, waving fields of sunflowers—orchestrated by a gentle wind and lit by an amber sunrise—comes the melodic song of the meadowlark, heralding the start of a warm July day. The grasslands and woodlands, lush and vibrant from the spring rains, are overflowing with wildflowers that exude a sweet, heady fragrance. New life is everywhere: elk and bison calves, deer and antelope fawns, great blue heron chicks, to name but a few.

Mid-summer is a wondrous time across this legendary landscape that we call the Black Hills. Here, the little meadowlark is the virtuoso of a symphony that has played time and again for tens of thousands of years.

To the Lakota and Cheyenne Indians, this land is Paha Sapa, or "hills that are black." "Herein lies the center of the Universe where dwells Wakan-Tanka, the Mysterious One…the Great Spirit." An old Lakota prayer tells us that it is here where "the Morning Star and the dawn which comes with it, the moon of the night, and stars of the heavens are all brought together." Here, the young men of the Lakota and Cheyenne came for their vision quests—a ritual that was part of the transition into manhood. Paha Sapa was and is a holy land, a place for reflection and spiritual invigoration.

Covering an area of about 125 miles by 65 miles, the Black Hills lie in western South Dakota, with a small part spilling over into northeastern Wyoming. The geological events that formed these hills began about 100 million years ago, making them even older than the Rocky Mountains.

Rising suddenly from surrounding seas of prairie grass, the hills leave the impression of having been placed here by divine hand. They encompass rugged and spectacular rock formations, canyons, gulches, open grasslands, tumbling streams, deep-blue lakes, fascinating caves, and vast forests of ponderosa pine—in addition to blue spruce, aspen, birch, willow, white oak, and cottonwood. The dark green of the pine absorbs light rather than reflects it and from afar gives the hills the appearance of being black, thus inspiring the name.

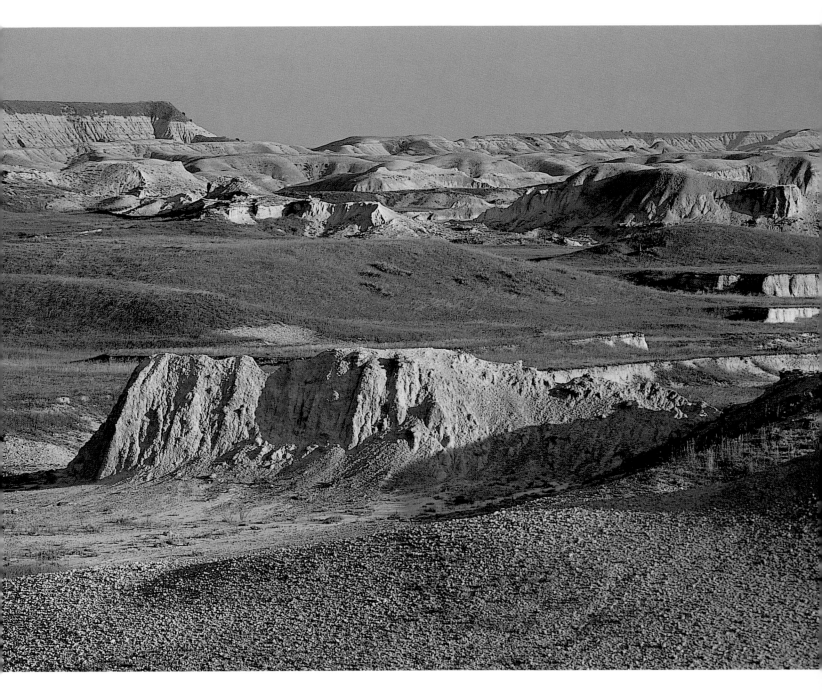

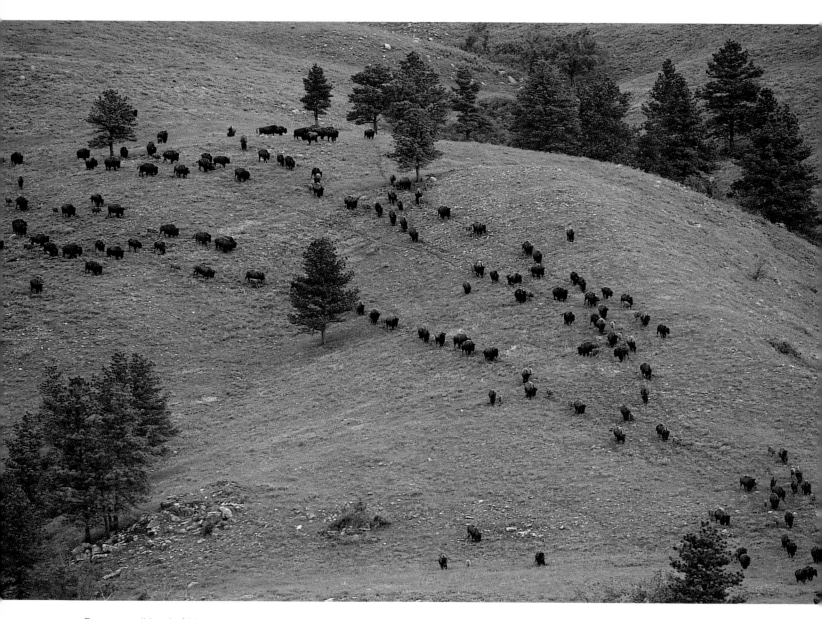

Even a small herd of bison pouring down this hillside in Custer State Park can inspire the imagination to picture a time when 60 million of these creatures roamed the middle third of North America.

Across this vigorous landscape roams magnificent wildlife in numbers reminiscent of a time long ago. There are elk, mule and whitetailed deer, antelope, mountain goats, and bighorn sheep. Huge prairie dog towns spread across the grasslands, while eagles, hawks, and falcons soar above. In the high country and on the prairies, there are lakes and wetlands with countless species of ducks and geese as well as great blue herons and trumpeter swans. Predatory mammals such as weasels, foxes, coyotes, bobcats, and elusive mountain lions are found throughout the region.

But for many the most spectacular and heartening sight lies in the herds of American bison that graze freely here on the open prairies as they have for millions of years. The bison herds in the Black Hills today total a little more than 2,000, and although that number is small when compared to the past—60 million once roamed the middle third of the North American continent—one can, with a little imagination, picture what was. The bison is more than simply another wildlife specimen; it has become an international symbol of the American West.

In that same sense, the Black Hills—with those rolling prairies, vibrant badlands, and jagged peaks—are a symbol, indeed the essence, of the American West.

Trekking across the marvelous grasslands alongside the bison, climbing in a rugged gorge splashed with autumn color, cross-country skiing through the snow of a high-country meadow, or simply immersed in the tranquility of a deep, fog-enshrouded lake on a cool spring morning, one can find the Paha Sapa of the Lakota and Cheyenne. As always, this land remains a place of the soul, still offering spiritual invigoration.

As you leave your own tracks across Paha Sapa, recall the eloquence of Black Elk, the famous Lakota holy man. "He who sees the Morning Star shall see more, for he shall be wise…and his thoughts shall rise as high as the eagles." ◆

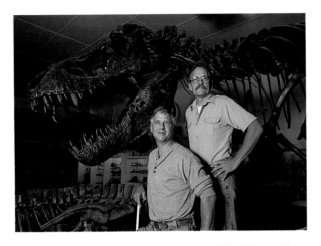

ABOVE: Brothers Neal and Pete Larson of the Black Hills Institute of Geological Research at Hill City pose with a re-creation of the *Tyrannosaurus rex* skeleton known as "Stan." Their institute is responsible for some the most important fossil discoveries in the region.

BELOW: Early spring at Deerfield Lake finds the waters free of ice and already showing new vegetation on the shoreline.

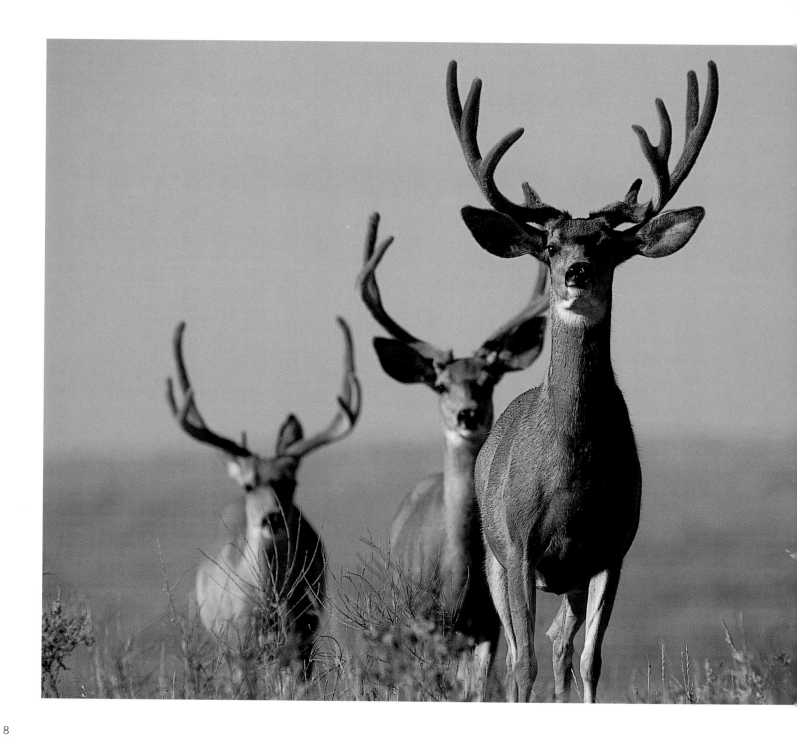

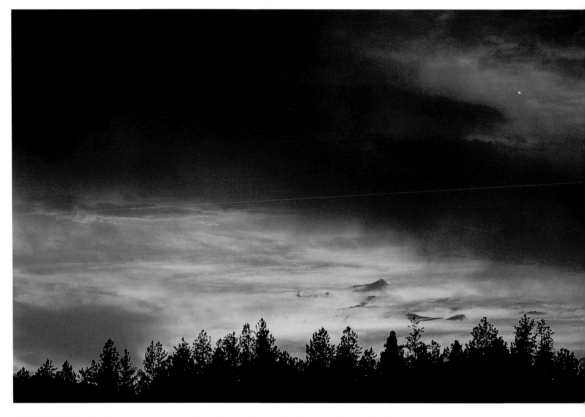

ABOVE: Brilliant colors creep across the sky at daybreak above a forested ridge in the southern Black Hills.

LEFT: With antlers still in velvet, these three large mule deer bucks move through a grassy ravine early on a mid-summer's morning in Wind Cave National Park.

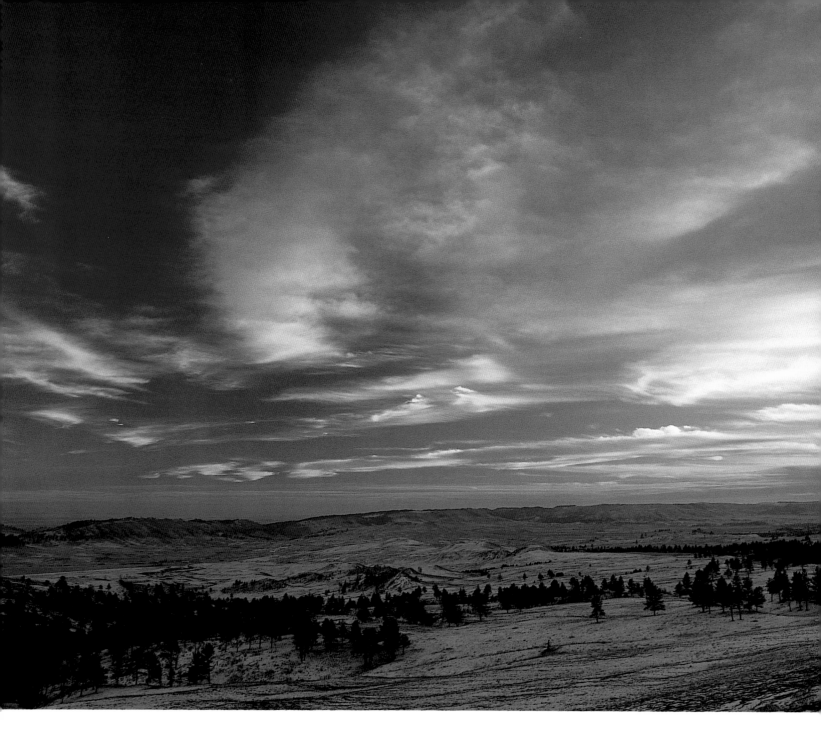

LEFT: A final whisper of sunlight warms the snowy ridges in a remote corridor of Wind Cave National Park following an early winter storm.

"Announced by all the trumpets of the sky, / Arrives the snow, and, driving o'er the fields, / Seems nowhere to alight: the whited air / Hides hill and woods, the river, and the heaven.... Ralph Waldo Emerson, "The Snow-Storm"

BELOW: With the amazing ease that is typical of these creatures, a mountain goat billy heads up a snow- and ice-covered peak in granite country near Mount Rushmore. These animals are not native to the Black Hills; they were introduced here during a management program in the early 1920s and have done very well. The population has grown to over 300.

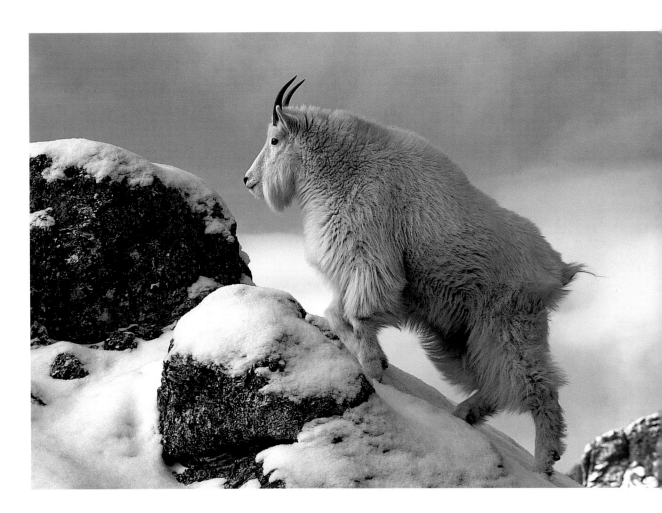

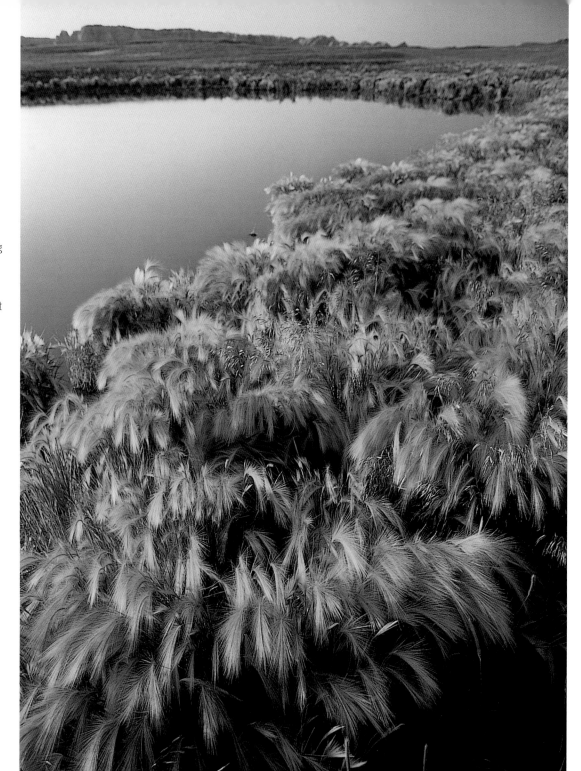

Lush green from the spring rains, the tall grass around a watering hole at Indian Creek is whipped about by the region's persistent wind.

RIGHT: A monarch butterfly derives a sweet reward as it drinks nectar from a leadplant. Native Americans called the leadplant "the bird's tree" because it is a favorite perch for the small songbirds of the prairie.

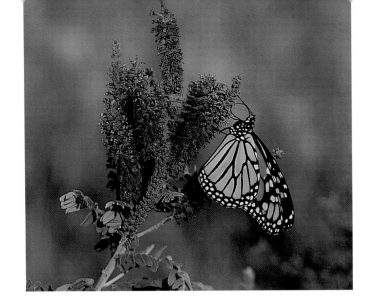

BELOW: A prairie dog pup surveys its world from atop a burrow in a prairie dog town on the grasslands. These prolific little clowns of the prairie are a great source of entertainment for all who stop to watch.

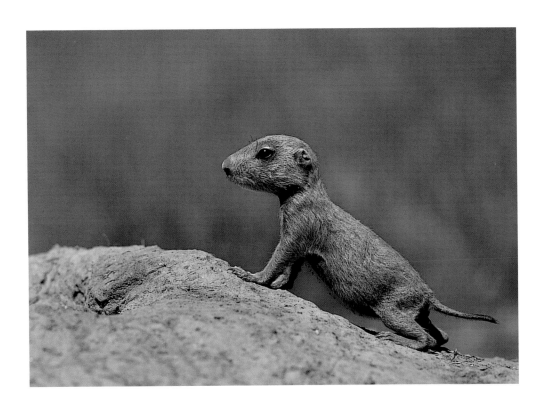

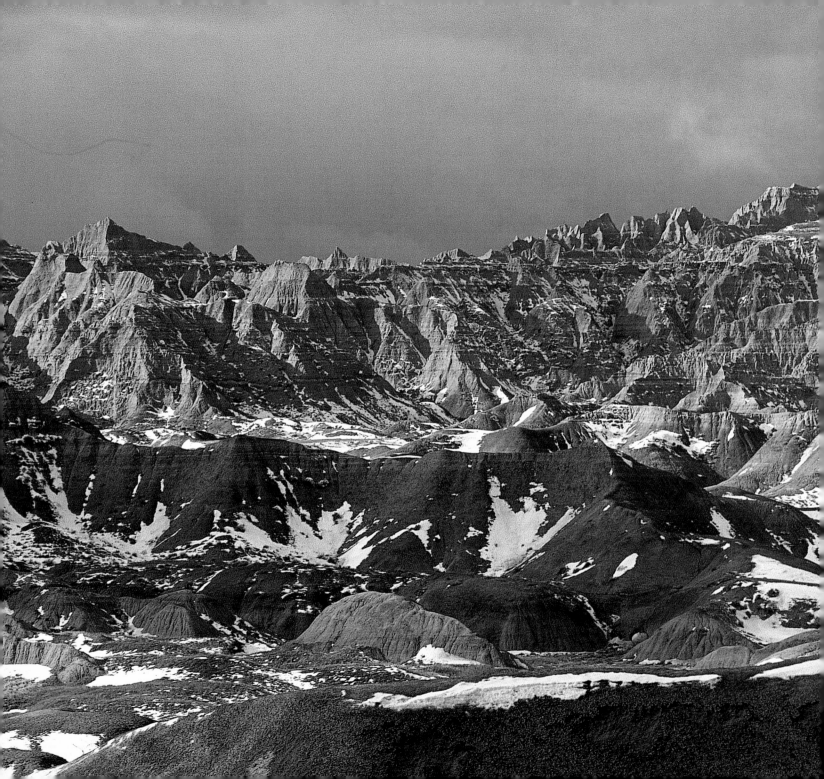

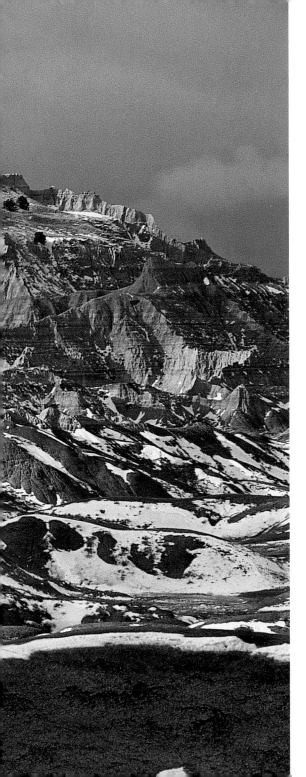

LEFT: The final light of the day illuminates this haunting winter landscape in Badlands National Park.

"To make a perfect winter day like this, you must have a clear, sparkling air, with a sheen from the snow, sufficient cold, little or no wind; and the warmth must come directly from the sun." Journal of Henry David Thoreau

BELOW: A playful bison calf tries out its new legs as it dashes about within the safety of the herd. At birth the coat is a reddish gold but turns chocolate brown at about the age of three months.

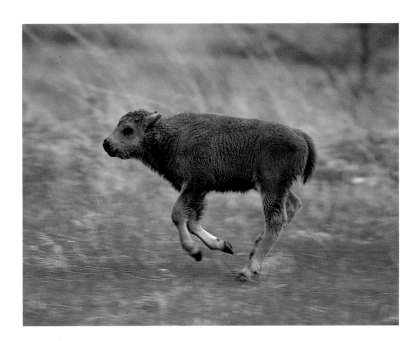

Aspen leaves fall into the waters of Spearfish Creek atop Roughlock Falls as autumn sets in at Spearfish Canyon.

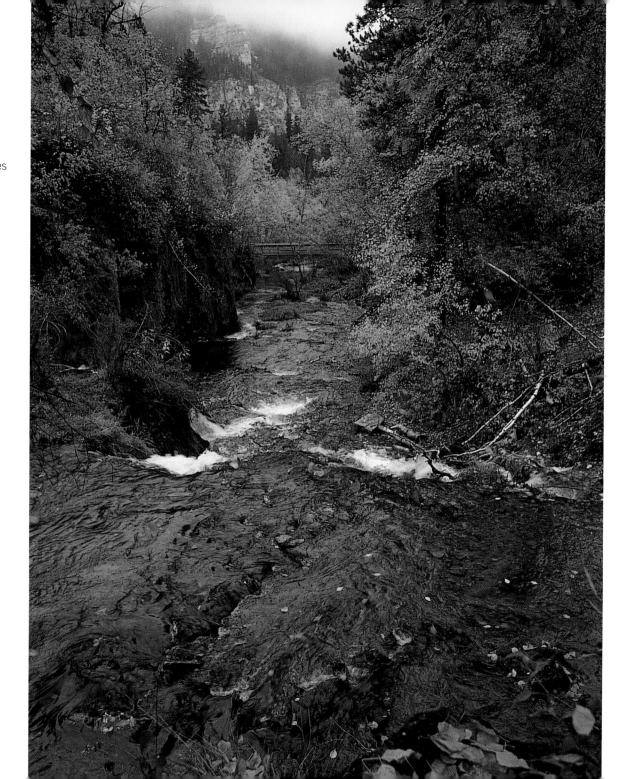

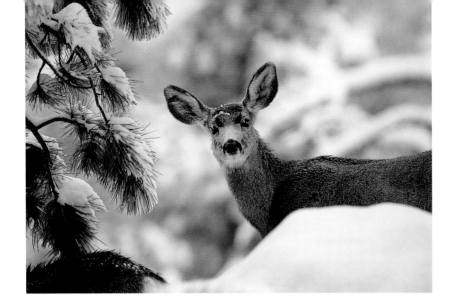

ABOVE: A mule deer doe searches for food in the fresh snow of a January morning in the high country of the central Black Hills.

RIGHT: Ice climber John Walker scales the frozen formations of Bridal Veil Falls in Spearfish Canyon.

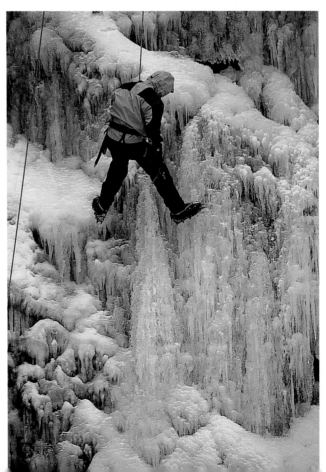

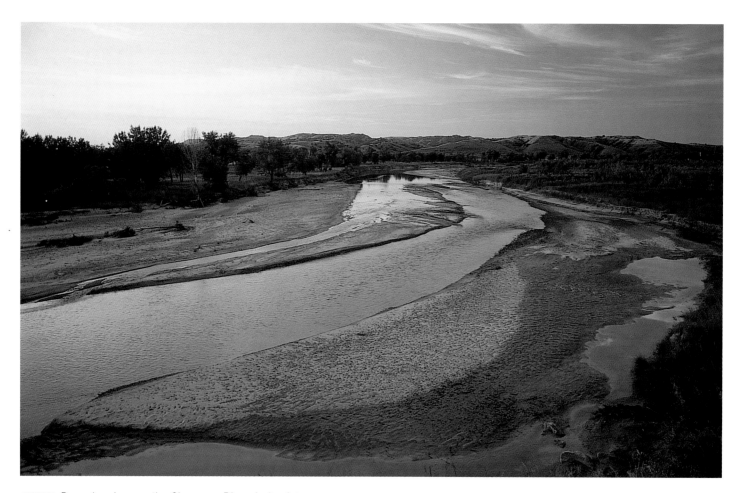

ABOVE: Dawn breaks over the Cheyenne River during late summer.

FACING PAGE: A bison cow and her young calf share affection during a moment of bonding in Custer State Park in early May. Most of the bison calves are born from late April to early June. Bison cows, which can weigh over 1,500 pounds, aggressively protect their young, so do not approach!

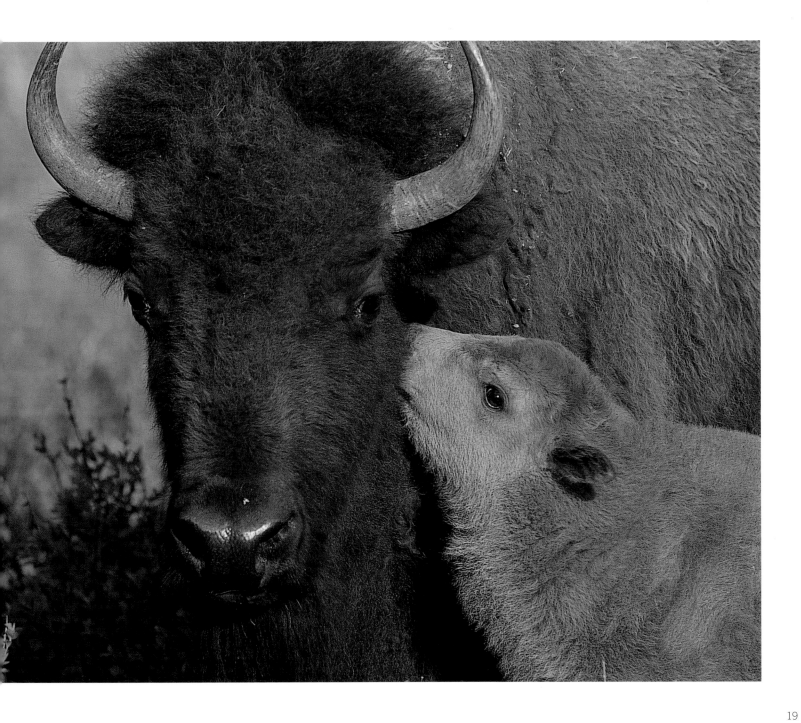

Another massive sculpture is in the works in the central Black Hills: the Crazy Horse Memorial. This monument to Crazy Horse, the great Lakota chief and warrior, will rise 62.5 stories when completed and is the creation of sculptor Korczak Ziolkowski. Also at the site are the Indian Museum of North America and the Native American Educational and Cultural Center.

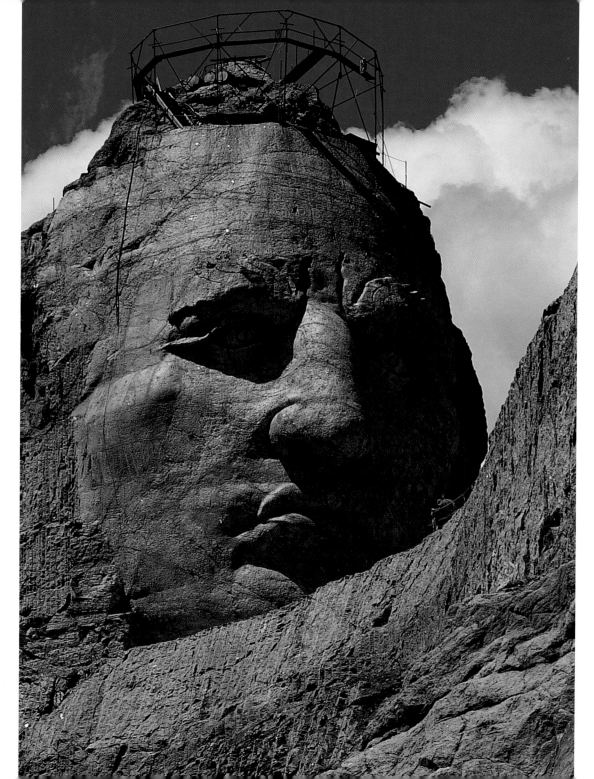

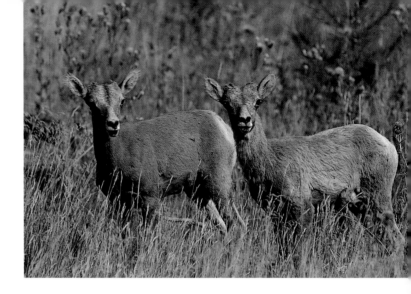

RIGHT: Two bighorn sheep lambs, each about a month old, graze in the tall summer grass in the Custer State Park high country.

BELOW: Autumn splendor graces the banks of the Cheyenne River in Hell Canyon.

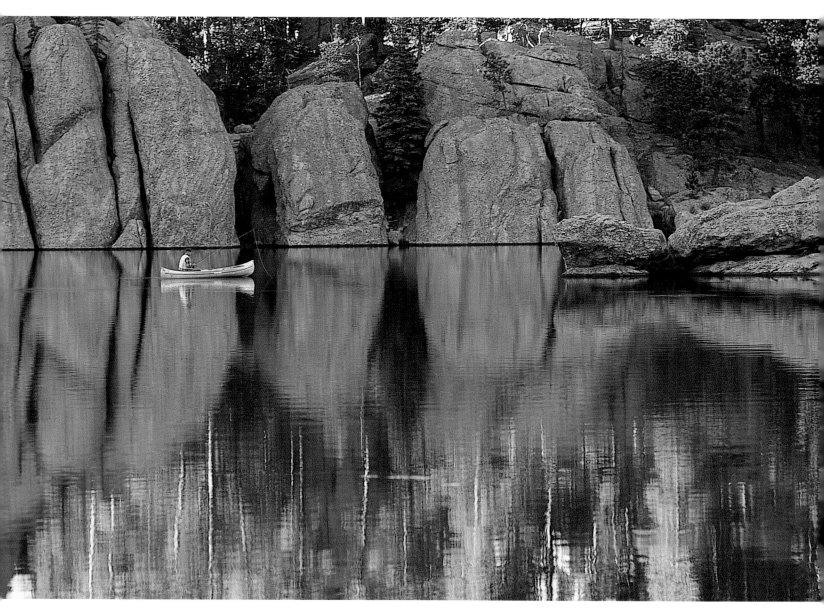

Reflections of shoreline rock formations are cast across the still waters of Sylvan Lake as a fly fisherman tries his luck for trout. This small high-country lake is a popular stop for anglers year round.

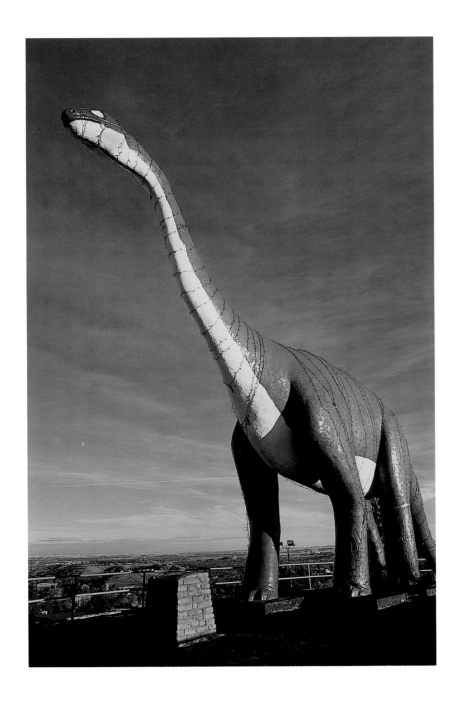

LEFT: All done up in Christmas lights, "Big Bronto," as this familiar landmark is known, overlooks Rapid City from atop Dinosaur Hill. Lying at the foot of the Black Hills, this small city of about 80,000 is stocked with restaurants, hotels, museums, and shopping malls.

BELOW: Western blue flag, or wild iris, is among the countless species of wildflowers that decorate the forests and meadows of the Black Hills.

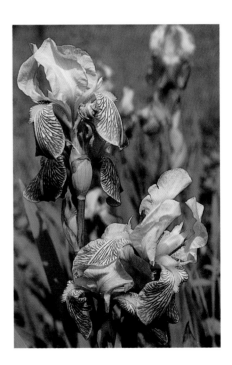

RIGHT: At dawn a heavy ground fog spreads soft and subtle colors across limestone country near the town of Custer.

BELOW: Rapid City's Journey Museum houses extensive exhibits on the human and natural history of the Black Hills region. First opened in 1997, the Journey Museum features the latest in audio-visual design and can provide a fun and informative experience for all.

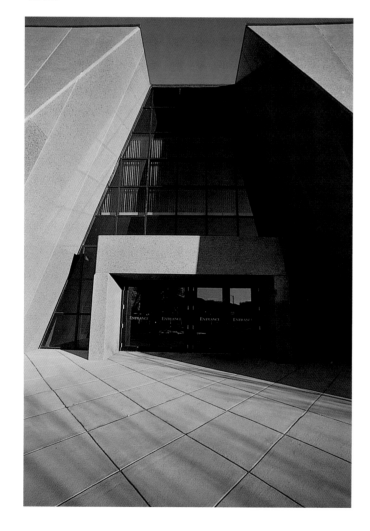

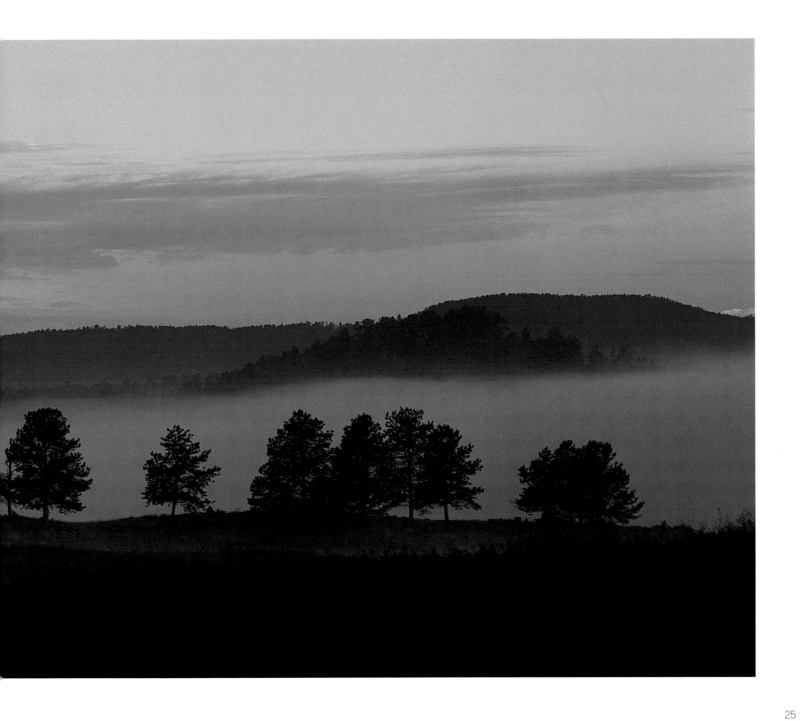

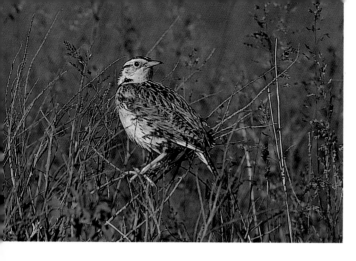

LEFT: The song of the western meadowlark is a familiar sound to those who walk the fields and forests of the Black Hills.

"Thou sing'st as if the God of wine / Had helped thee to a Valentine...." William Wordsworth, "O Nightingale! Thou Surely Art"

BELOW: In early autumn this chubby prairie dog has done a very good job building up a fat reserve for the coming winter.

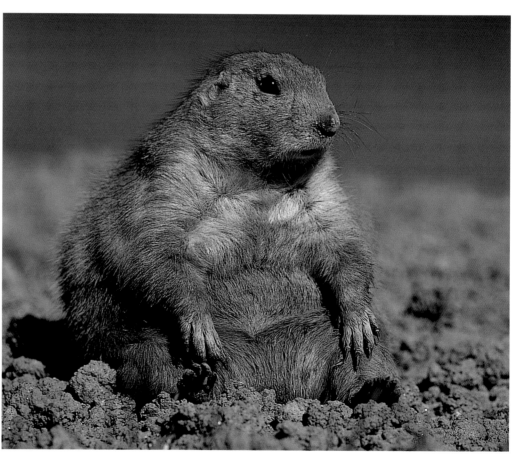

May wildflowers adorn the banks of French Creek in the central Black Hills.

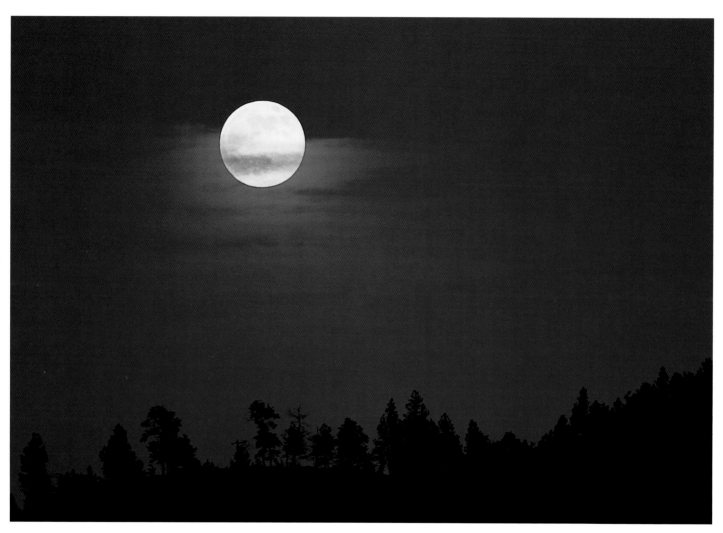

A June moon rises over a forested ridge in Wind Cave National Park.

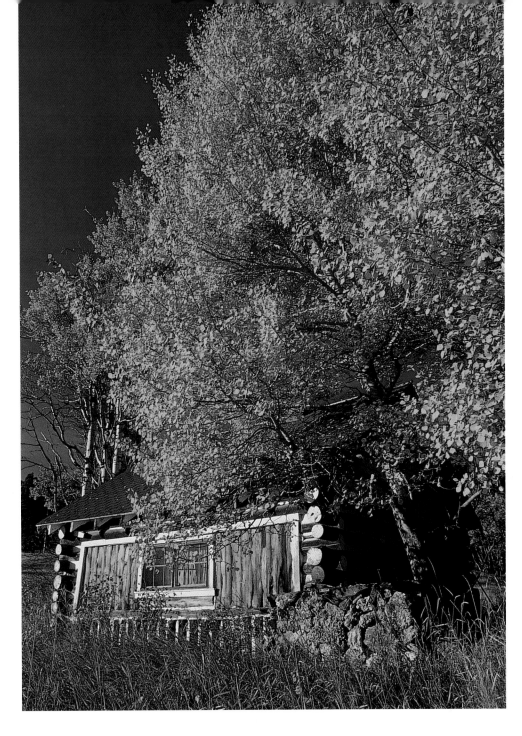

This well-kept old cabin, built during the early twentieth century, is framed by an aspen tree at the peak of autumn color.

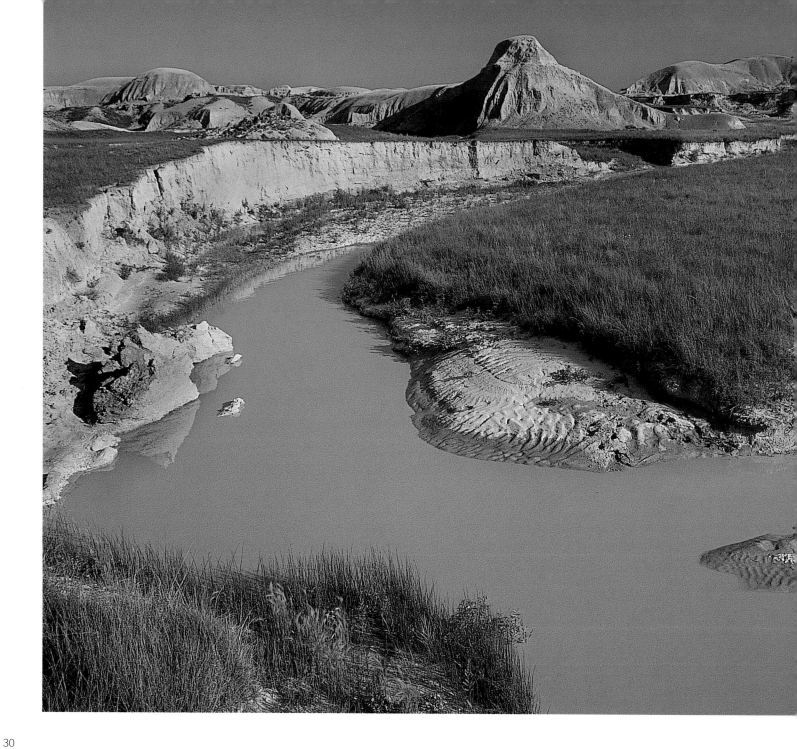

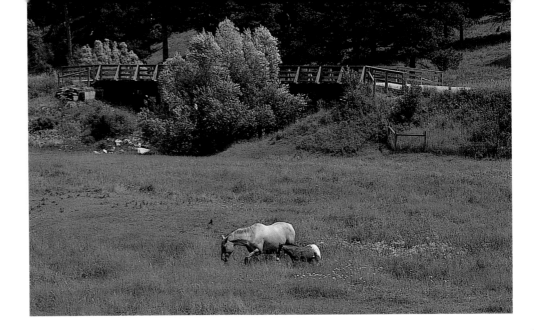

ABOVE: A mare and her foal browse through the wildflowers near a bridge that is part of the George S. Mickelson Trail. Completed in the late 1990s, this trail is open to hikers, cyclists, and cross-country skiers. It runs north and south through the entire length of the Black Hills, about 125 miles.

RIGHT: The three-nerve fleabane is common in much of the Black Hills and the Rocky Mountains. It inhabits open woodlands and other semi-shaded places.

LEFT: The harsh and rugged beauty of Indian Creek Basin gives rise to the thought that this land could have been a testing ground for life forms. Whatever survives here could flourish most anywhere.

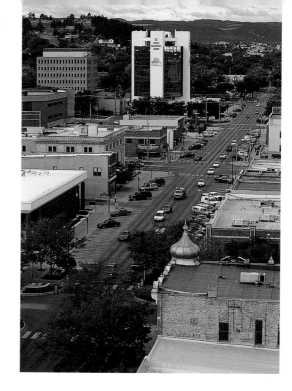

RIGHT: The Black Hills rise up in the background of Rapid City's downtown in this view from atop the historic 1928 Hotel Alex Johnson.

BELOW: The seemingly lunar landscape of the Badlands.

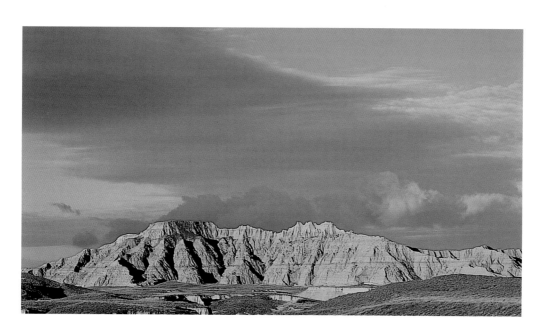

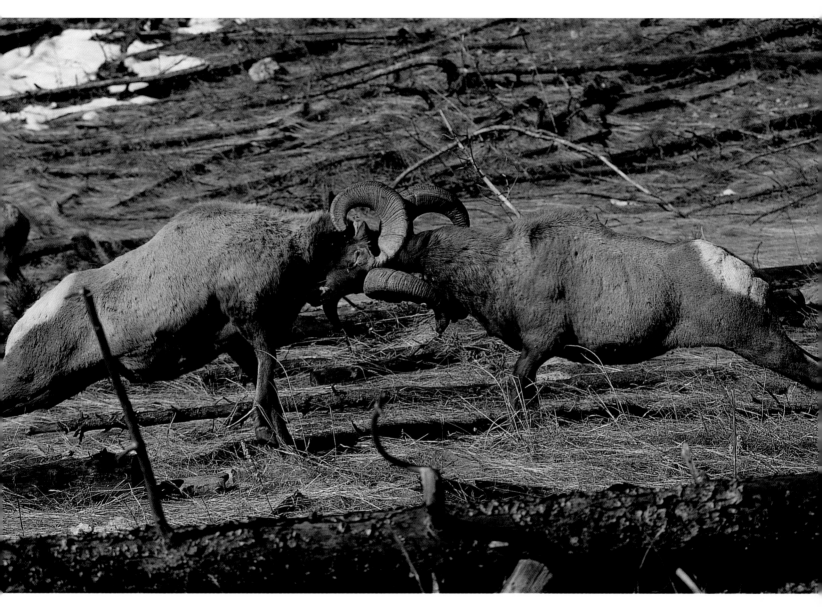

Two bighorn sheep rams engage in a rut battle among fallen timbers in a high-country meadow. During late autumn and early winter, the clash of these mighty centurions echoes from the canyons of the central Black Hills as they compete "for the hand of the lady."

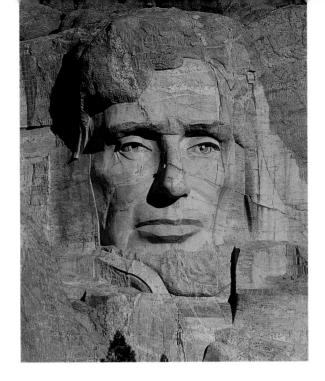

LEFT: This perspective of the face of Abraham Lincoln at the Mount Rushmore National Memorial can only be seen from high on the surrounding granite spires. Lincoln was one of sculptor Gutzon Borglum's favorite subjects and he carved several likenesses of this famous American president.

BELOW: With a few patches of snow still remaining, this newborn foal in the Black Hills Wild Horse Sanctuary is already curious about the big world around him.

FACING PAGE: The Cheyenne River meanders through this southern Black Hills canyon as the last leaves of autumn fall from the cottonwoods.

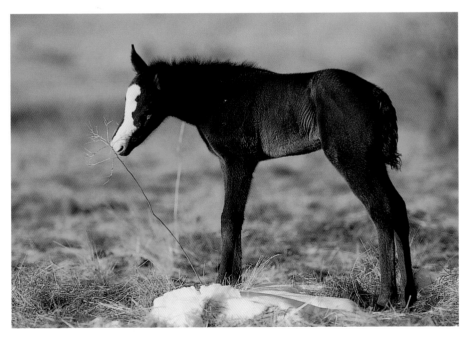

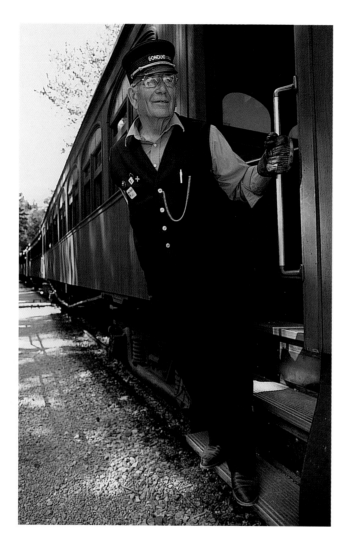

ABOVE: With all passengers aboard, conductor Dave Powell calls to the locomotive engineer that all is ready for the 1880 Train of the Black Hills Central Railroad to depart from the depot in Keystone.

RIGHT: Engine 104 steams through a meadow on original tracks heading to Hill City from Keystone—it does so several times a day during the summer season. This excursion train provides a scenic 20-mile round trip and a great feel for what the old railroad was like as it passes old mining camps, beaver dams, and grazing wildlife.

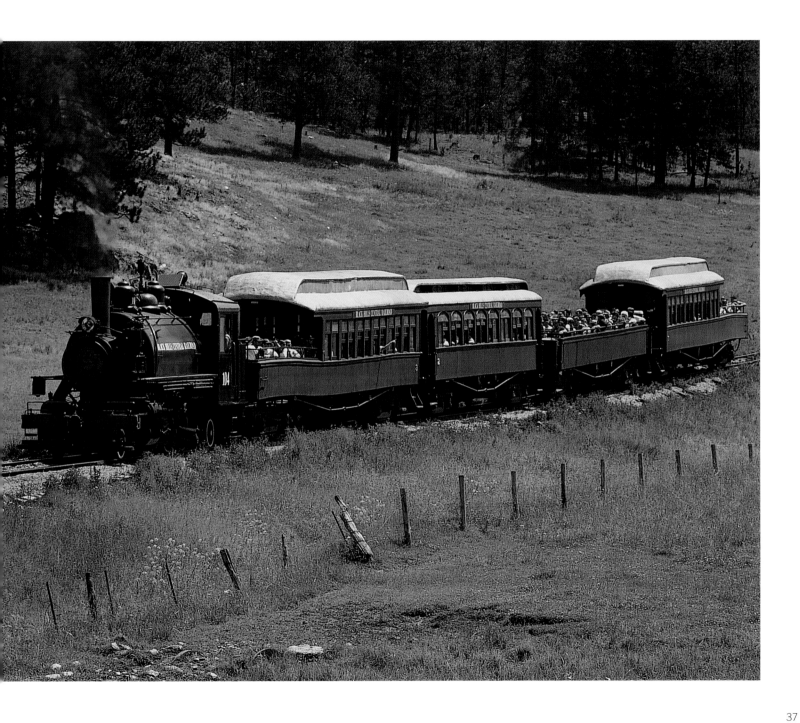

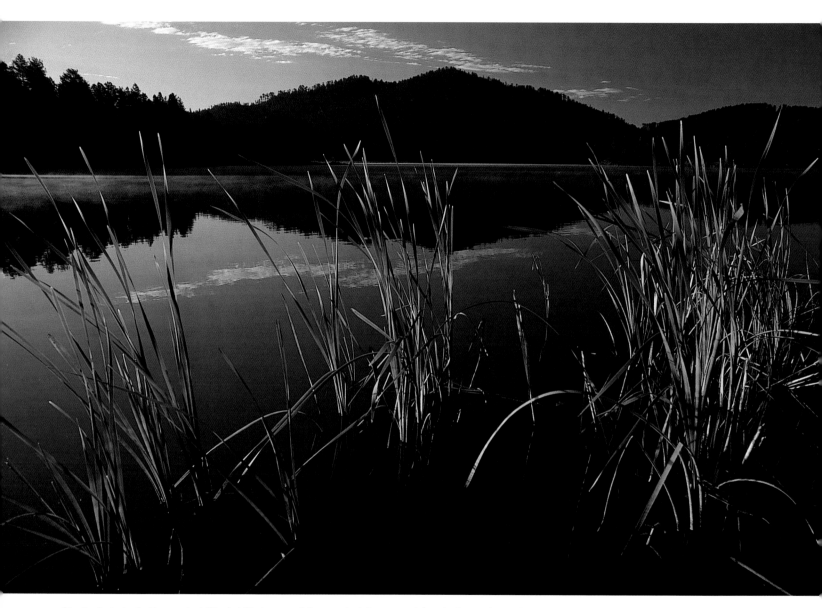

Stockade Lake in the central Black Hills is one of the most picturesque lakes in the entire region.

"And on that morning, through the grass / And by the steaming rills / We travll'd merrily, to pass / A day among the hills." William Wordsworth, *"The Two April Mornings"*

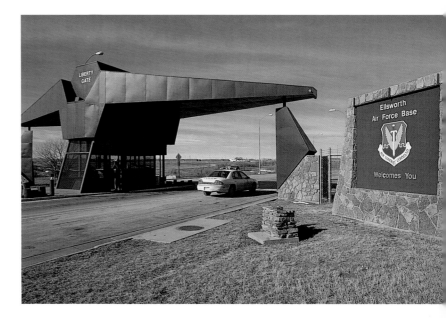

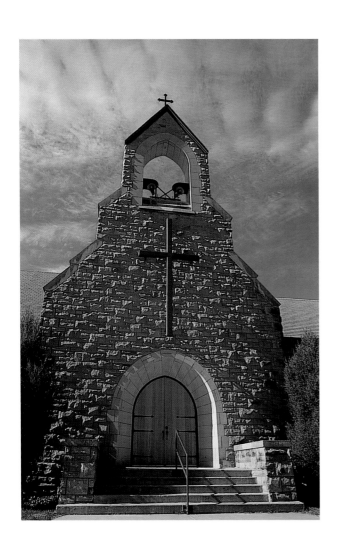

ABOVE: Ellsworth Air Force Base lies on the prairie about 8 miles east of Rapid City. The base originated during World War II as a post of the old Army Air Corps where B-17 bomber crews were trained. During the Cold War the base was an important part of the Strategic Air Command, complete with a B-52 bomber wing and control of Minuteman Missile sites scattered throughout the state. Today Ellsworth is base for a B-1 bomber wing.

LEFT: The Episcopal Church of Hot Springs is a good example of the unique sandstone architecture typical of this southern Black Hills town. The town of Hot Springs originally grew as a health spa to which thousands flocked each year for the medicinal hot springs, thus earning its name.

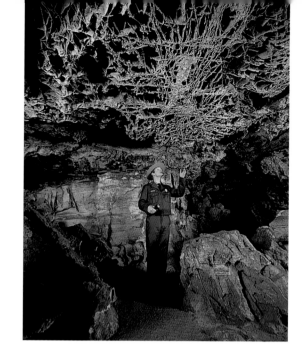

RIGHT: A park ranger tells visitors about the lacy boxwork formations on the ceiling in Wind Cave. The cave—which has a year-round temperature of 53 degrees—along with 28,295 acres of grasslands, pine forests, hills, and ravines make up Wind Cave National Park, which was so designated in 1903 by President Theodore Roosevelt.

BELOW: Mist rises from the Fall River as it runs through the middle of Hot Springs on a particularly cold February morning.

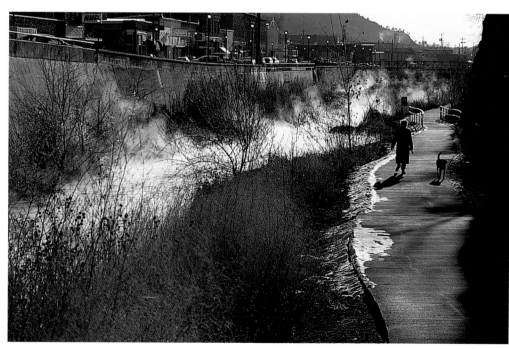

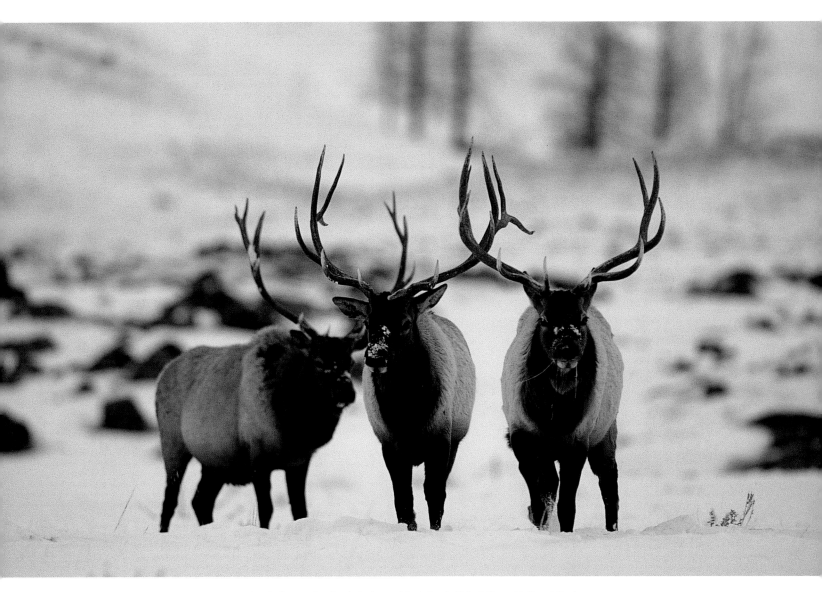

Three Rocky Mountain bull elk forage for food during mid-winter in Wind Cave National Park.

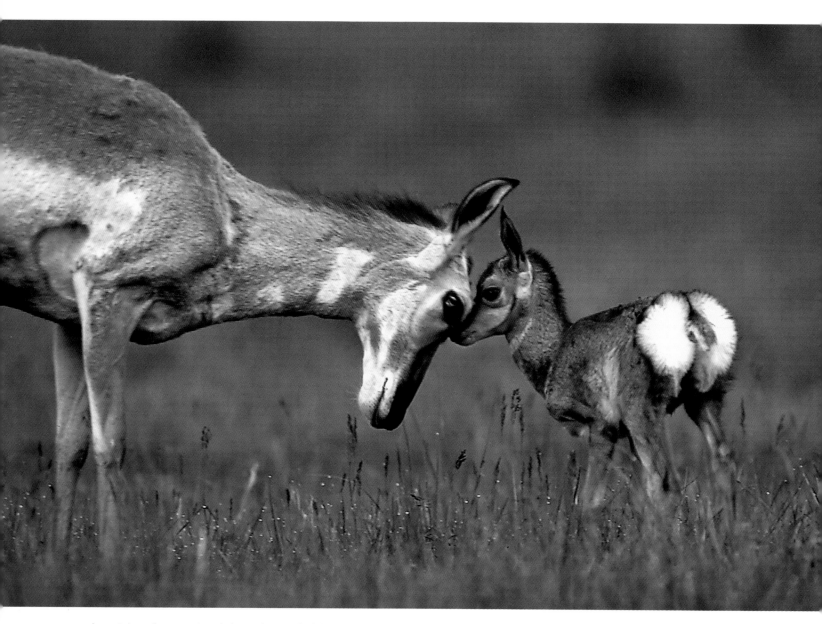

An antelope (or pronghorn) doe enjoys a playful moment with her little buck fawn, no more than a few days old, in Custer State Park. Capable of speeds of 65 miles per hour and possessing excellent eyesight, no animal is better suited to the prairies than these beautiful creatures. So unique are they that the antelope—which is more closely related to goats than to deer—is the only member of its genus, *Antilocapra*.

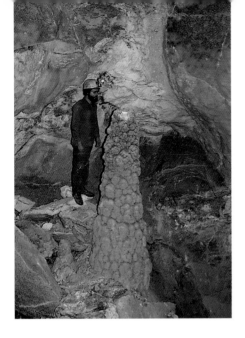

LEFT: With vast areas still unexplored, pristine Jewel Cave is recognized as the third-longest cave in the world. PHOTO BY STEVE BALDWIN

BELOW: Huge granite formations rise up from the ponderosa pine forests of the central Black Hills.

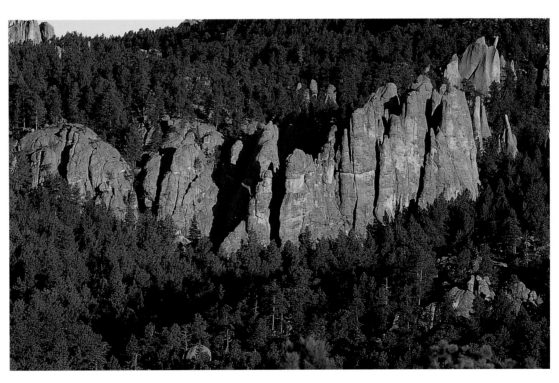

Aspen trees show their autumn gold in an area of Spearfish Canyon in the northern Black Hills where the final scenes of the epic movie *Dances With Wolves* were filmed. Almost all of this Academy Award–winning movie was shot on location in the Black Hills region during the early 1990s.

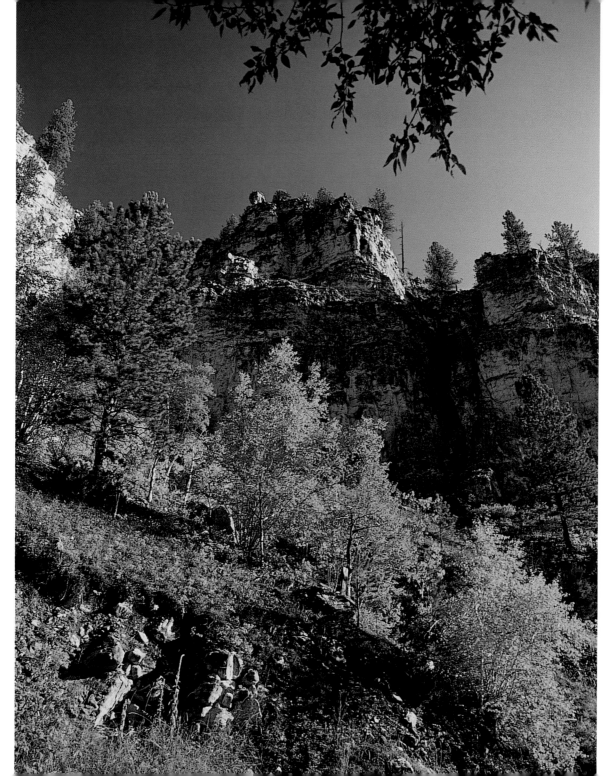

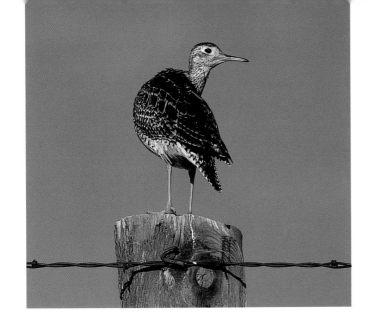

LEFT: An upland sandpiper stands atop a fencepost on a June morning in the Buffalo Gap National Grasslands. These attractive birds are found throughout the prairies.

BELOW: This hoodoo is the result of years of wind erosion stripping away the softer clays beneath harder and more resistant surfaces of sand mixed with groundwater.

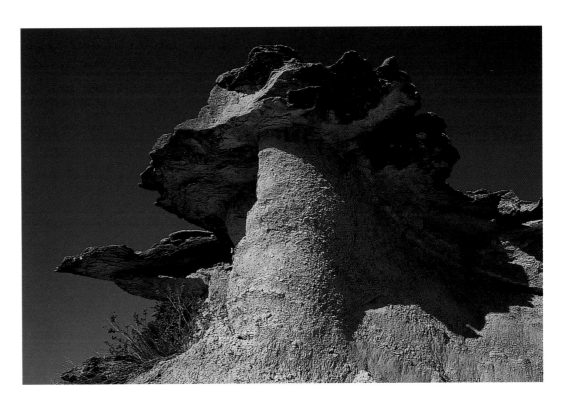

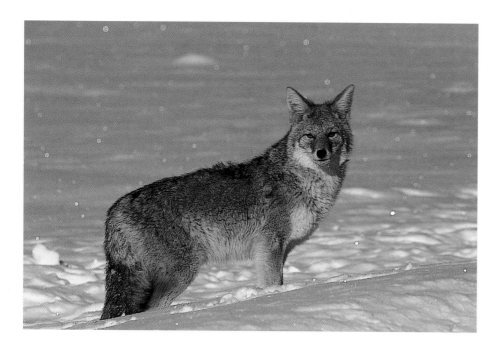

ABOVE: A coyote stops for a moment in the deep snow of January on Wind Cave National Park land before continuing its search for mice and other rodents.

RIGHT: Blowing snow flies through this ponderosa pine forest during a blizzard in Custer State Park.

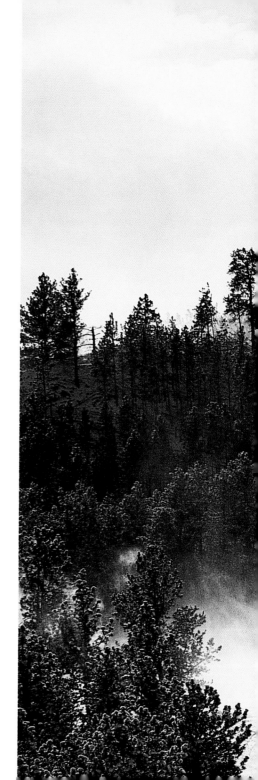

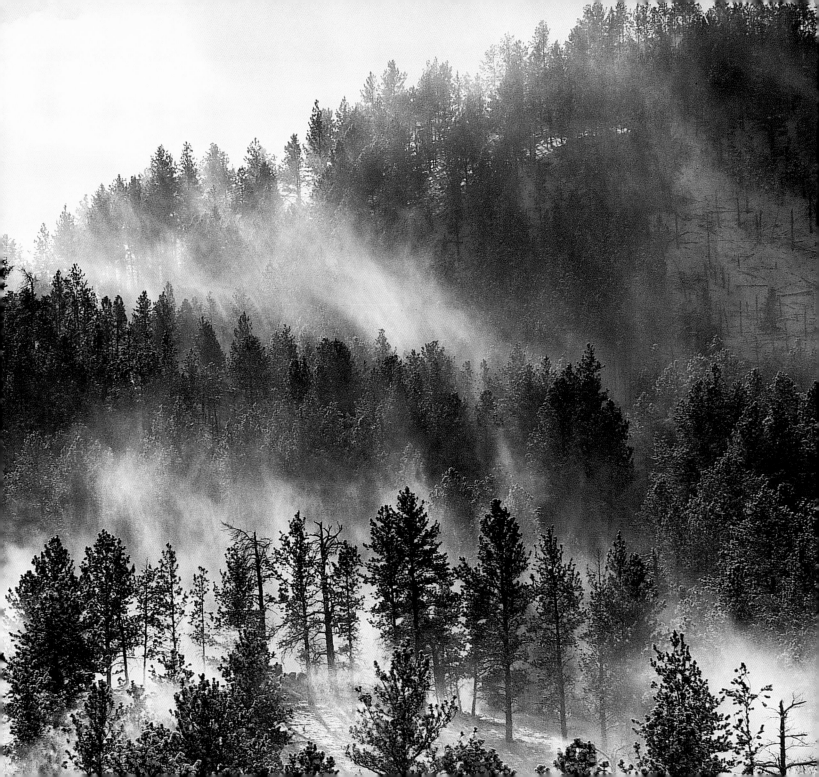

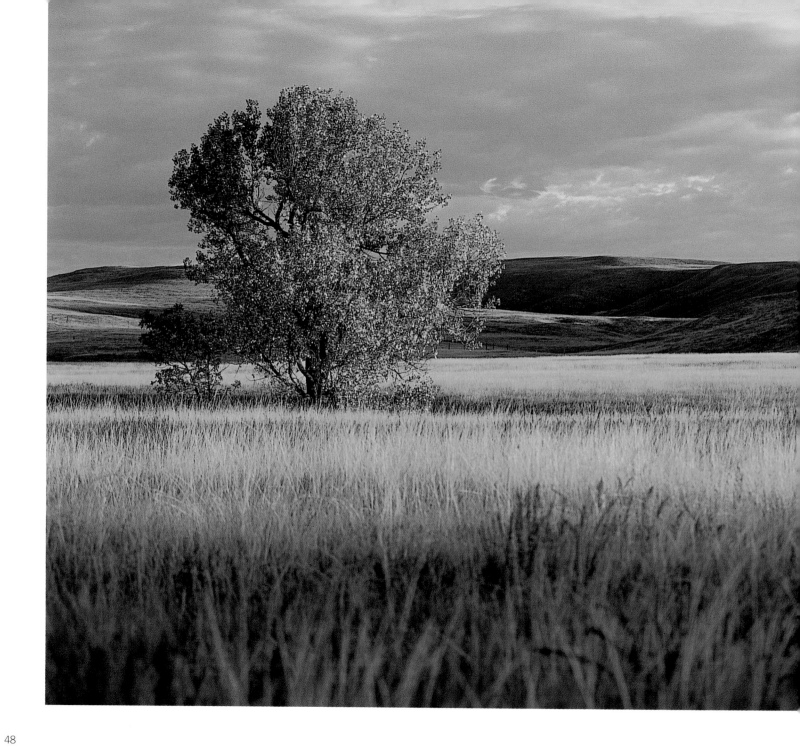

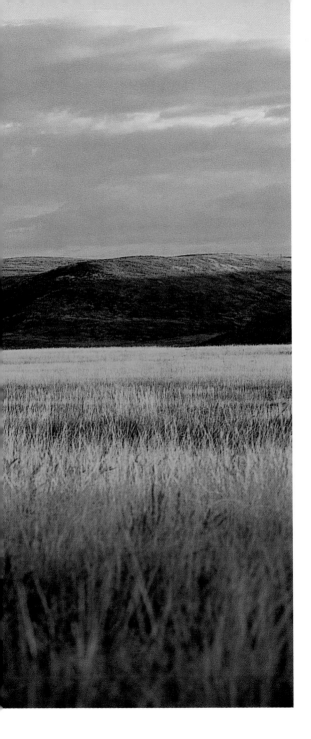

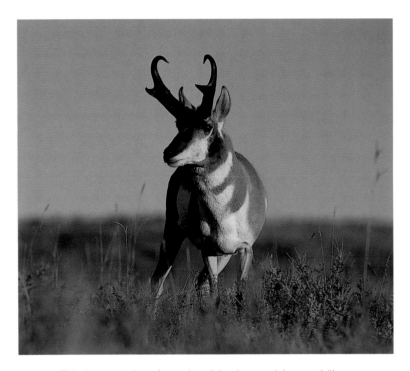

ABOVE: This large antelope (pronghorn) buck was nicknamed "Lame Johnny" because Lame Johnny Creek runs through his territory in Custer State Park. This famous resident of the park is believed to have died during the winter of 2000–2001.

LEFT: A lone cottonwood tree standing in a southern Black Hills prairie turns a brilliant yellow in fall.

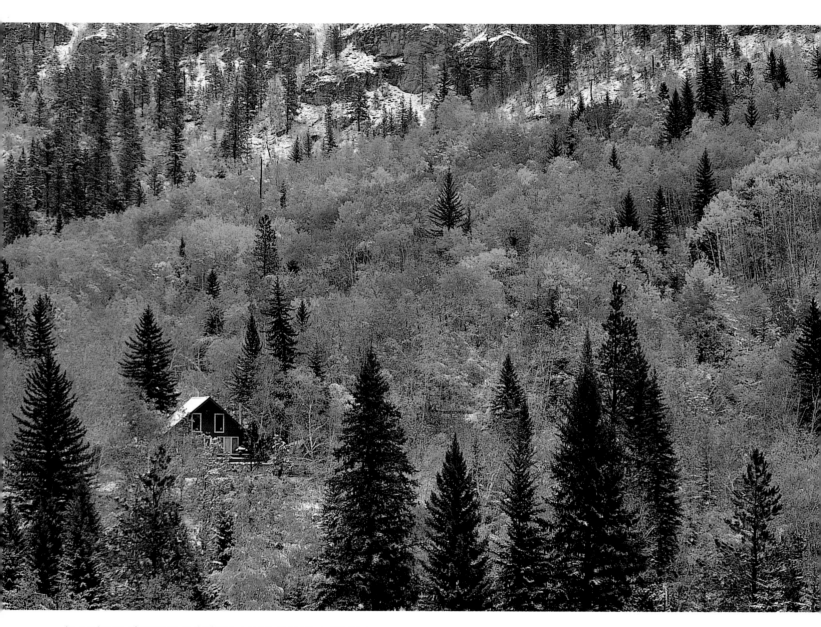

In a mixture of autumn and winter, a large cabin is nestled among aspen trees dusted with light snowfall in Spearfish Canyon during mid-October.

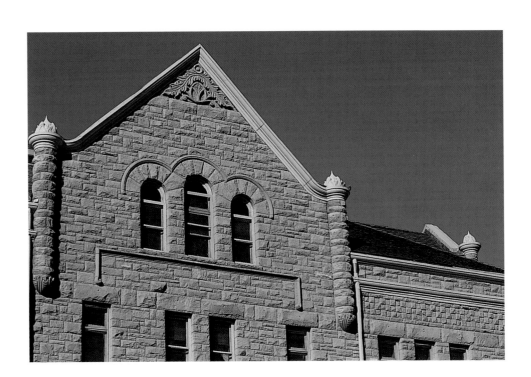

RIGHT: An old wagon sits at the base of Calamity Peak near the area where General George Custer's 1874 Black Hills Expedition first discovered gold.

BELOW: This old sandstone school building in Hot Springs is now a museum.

RIGHT: A large, old cottonwood tree stands beside a hard-surfaced dirt road running through the Boland Ridge area in the western corner of Wind Cave National Park.

BELOW: A sharp-tailed grouse hen stands vigilant before her nest of chicks, which is hidden in the tall grass a few feet behind her. Very similar to prairie chickens, these birds inhabit the grasslands, sagebrush, woodland edges, and river canyons of the Black Hills area.

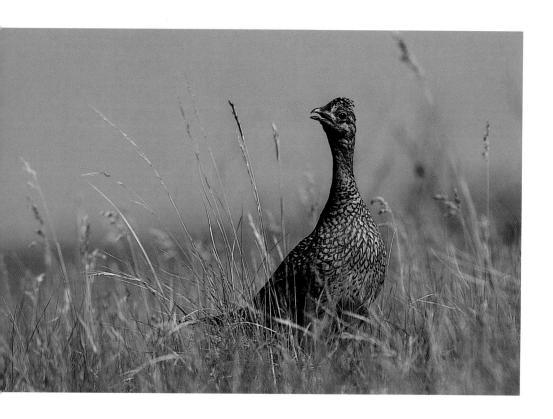

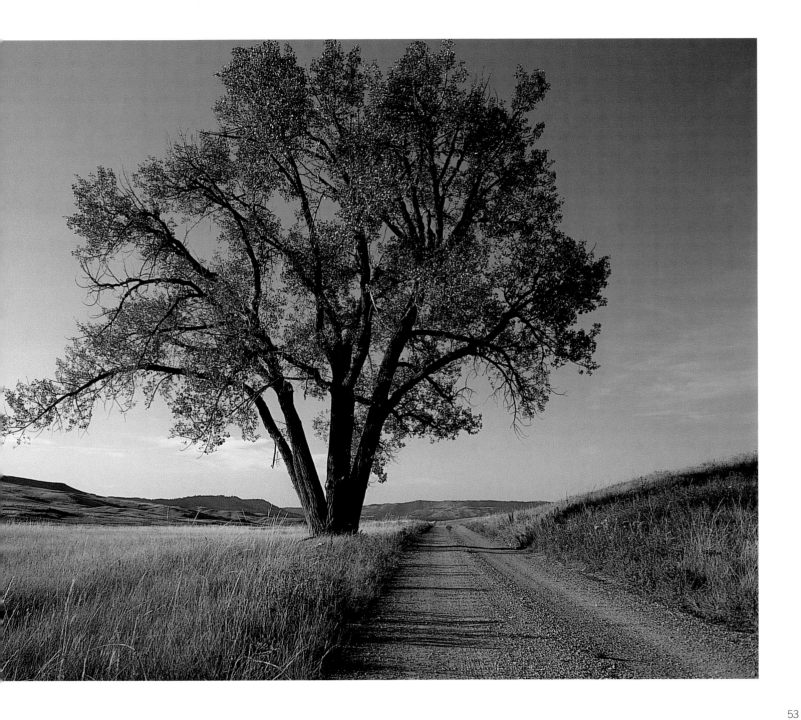

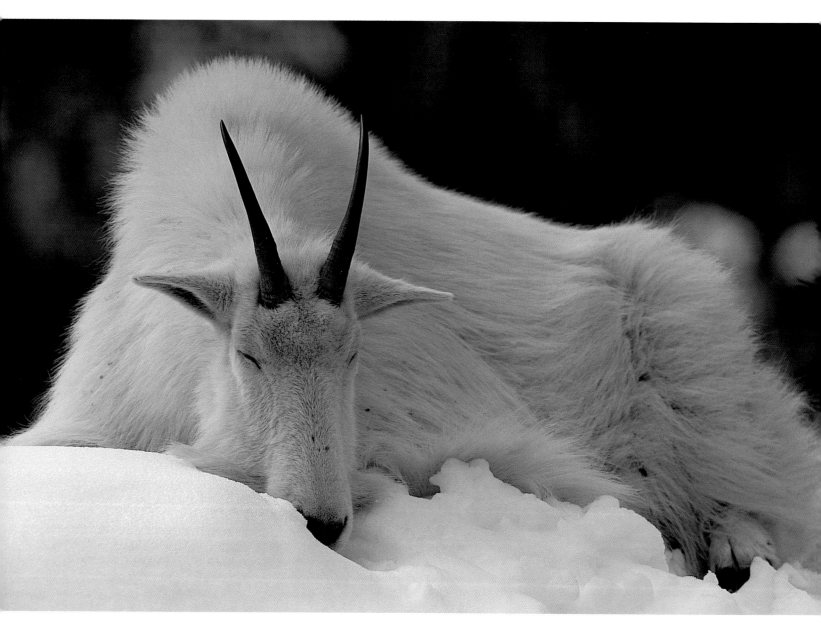

A mountain goat billy takes a nap in a snow drift on a rocky ledge in the central Black Hills' granite country. Nature's ultimate mountaineers, these wonderful creatures perform some incredible climbing feats.

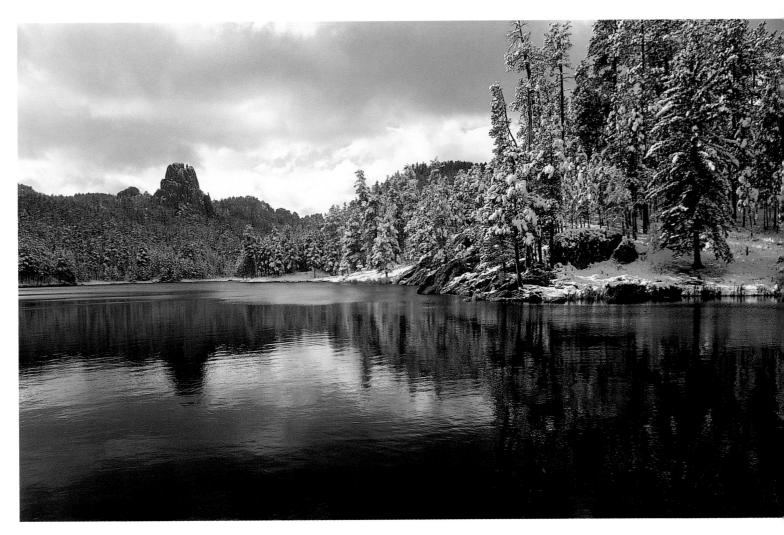

This evening scene during early winter at Horsethief Lake in the central Black Hills reflects some of poet Robert Frost's thoughts in "A Winter Eden."

"A feather-hammer gives a double knock. / This Eden day is done at two o'clock. / An hour of winter day might seem too short / To make it worth life's while to wake and sport."

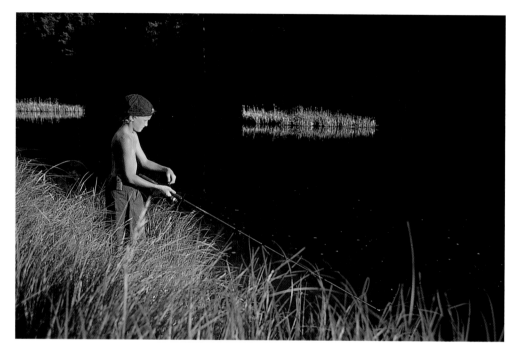

ABOVE: This young angler has high hopes of landing one of the huge trout that are known to inhabit the waters of Mitchell Lake near Hill City.

RIGHT: This high-country meadow near Rochford is saturated with black-eyed susans and ox-eye daisies during mid-summer.

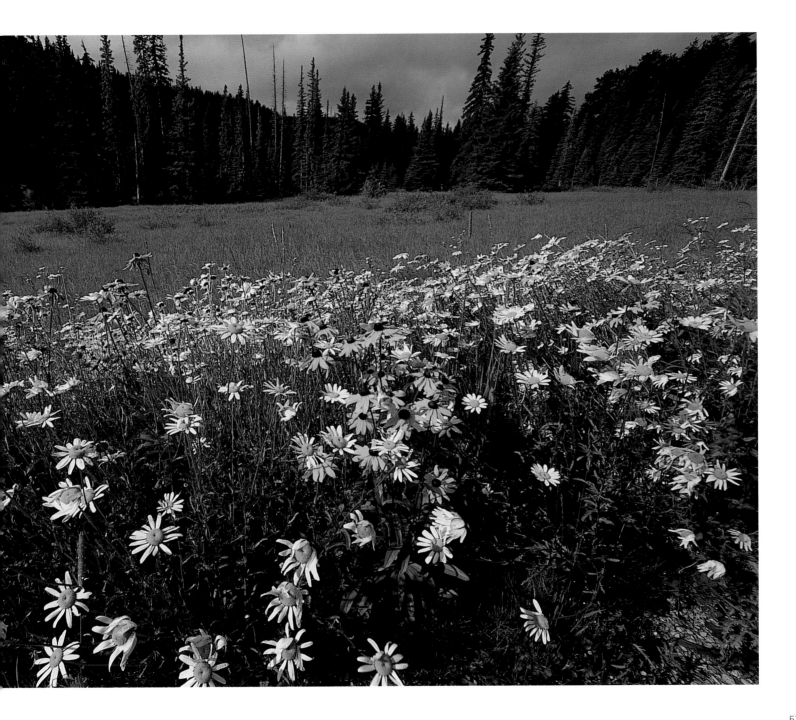

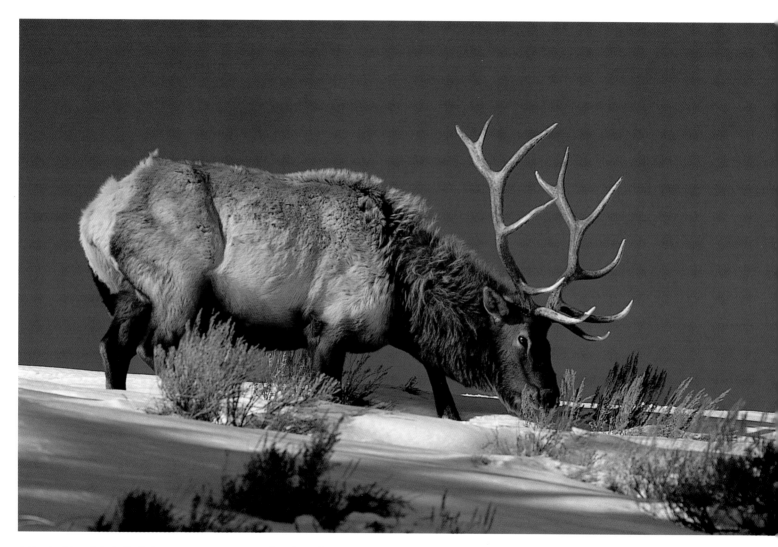

A Rocky Mountain bull elk browses on sage protruding from the snow
on a cold, but sunny, January day on Wind Cave National Park land.

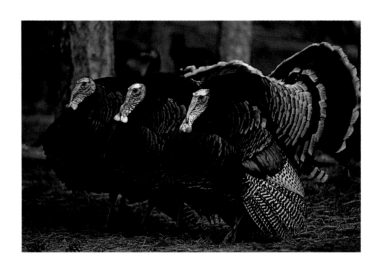

RIGHT: Three wild turkey toms form what looks like a chorus line as they fan and strut for the hens during the spring rut.

BELOW: The historic Franklin Hotel on Main Street in Deadwood provides luxury, entertainment, and gambling for the faster set. The old northern Black Hills town is packed with lavish casinos and historic landmarks.

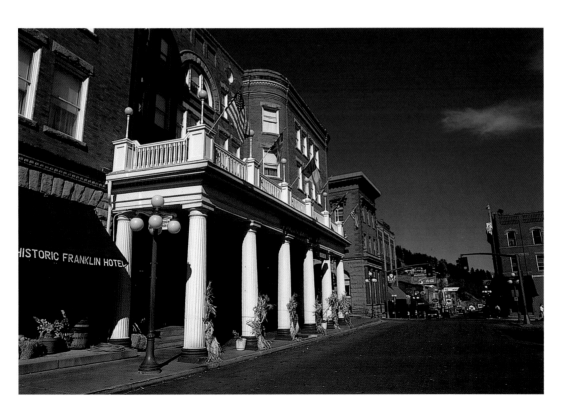

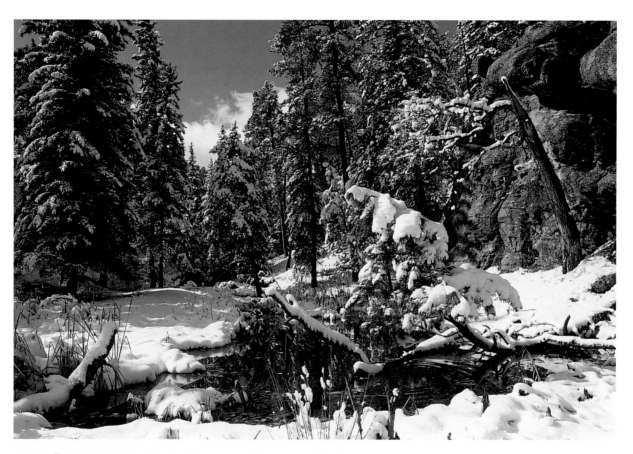

ABOVE: The sun warms a mid-winter's morning following a night of snow in a central Black Hills canyon.

RIGHT: Two bighorn sheep ewes cross the frigid waters of French Creek.

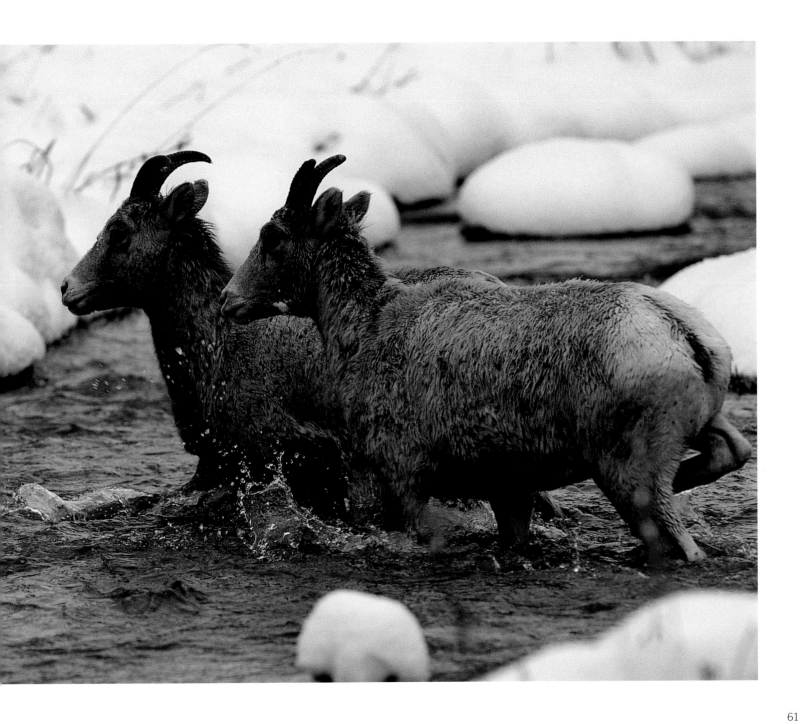

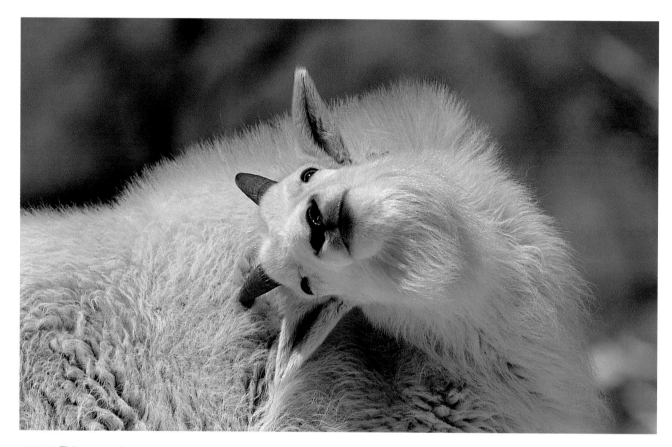

ABOVE: This mountain goat nanny uses one of her rapier-like horns to scratch herself.

FACING PAGE: Framed by its unique granite formations, Sylvan Lake is already frozen over in late November and ready for the ice fishermen.

"There are two seasons in winter; when the ice of the ponds is bare, blue and green, a vast glittering crystal—and when it is all covered with snow and slush; and our moods correspond." Journal of Henry David Thoreau

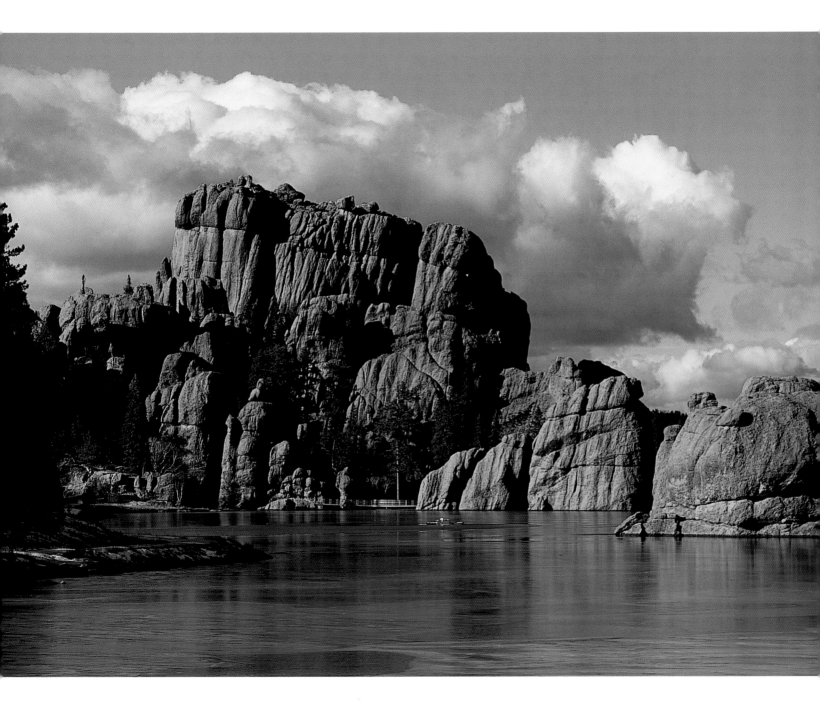

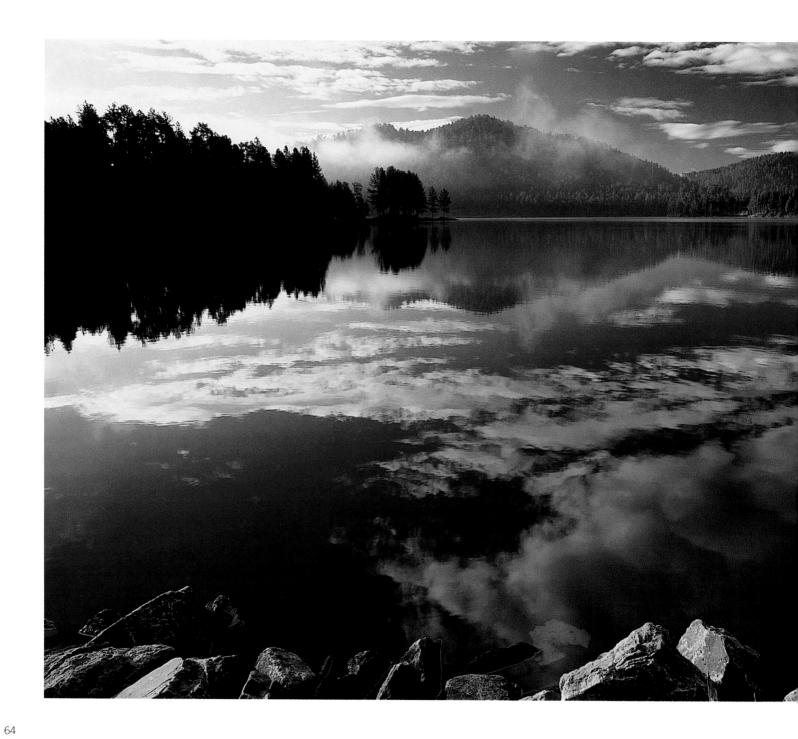

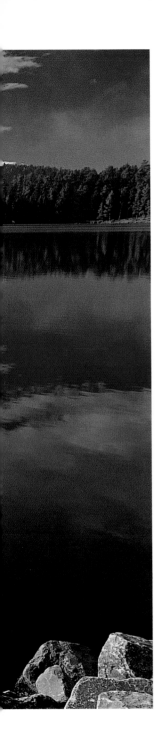

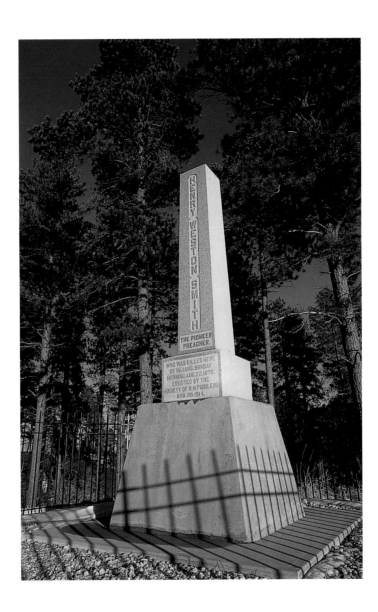

LEFT: A monument atop Preacher's Hill near Deadwood commemorates a clash between Native Americans and white settlers in which preacher Henry Weston Smith was killed.

FAR LEFT: The foggy mists of Stockade Lake near Custer rise from waters that are still chilly even on a June morning such as this one.

ABOVE: The withered shrubs and leafless cottonwood trees of winter take on a festive look as they are decorated by fresh snowfall.

RIGHT: A group of Rocky Mountain elk are silhouetted against the dawn sky as they browse across Boland Ridge on Wind Cave National Park land.

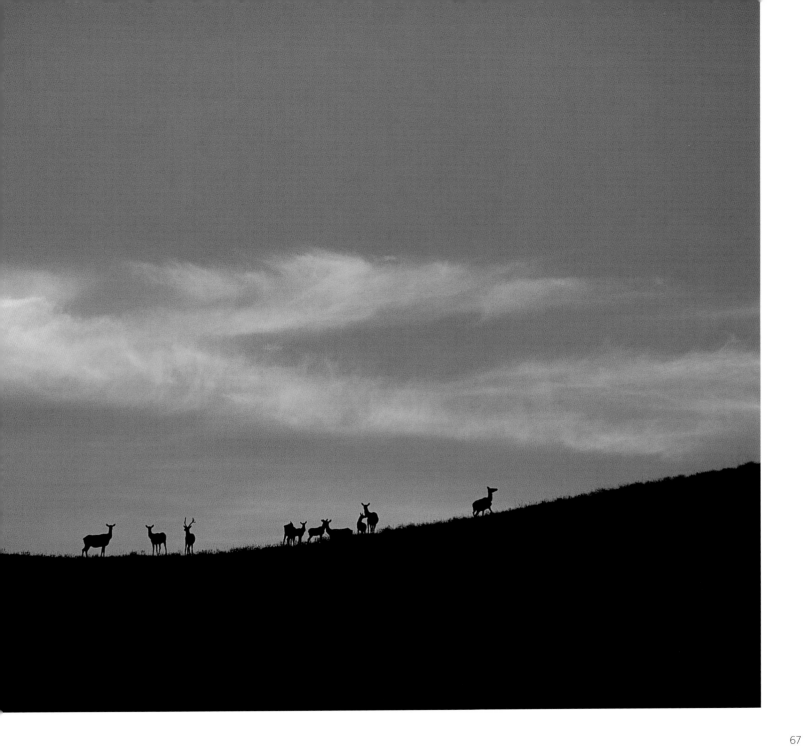

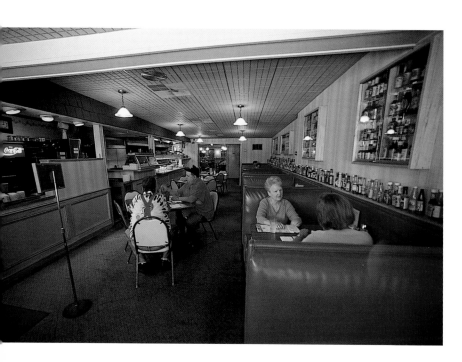

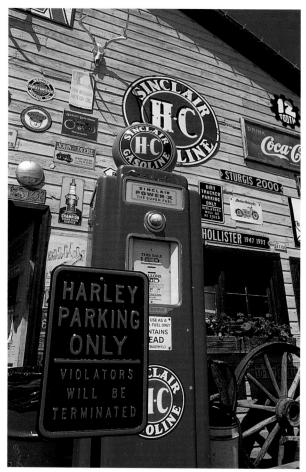

ABOVE: Bob's Restaurant in Sturgis is a favorite for locals year round. But when the Motorcycle Rally begins in early August, slow and quiet times in this town of about 8,000—like this morning in early summer—are but a memory.

RIGHT: This parking sign demonstrates how motorcycle-friendly Sturgis becomes during the Rally.

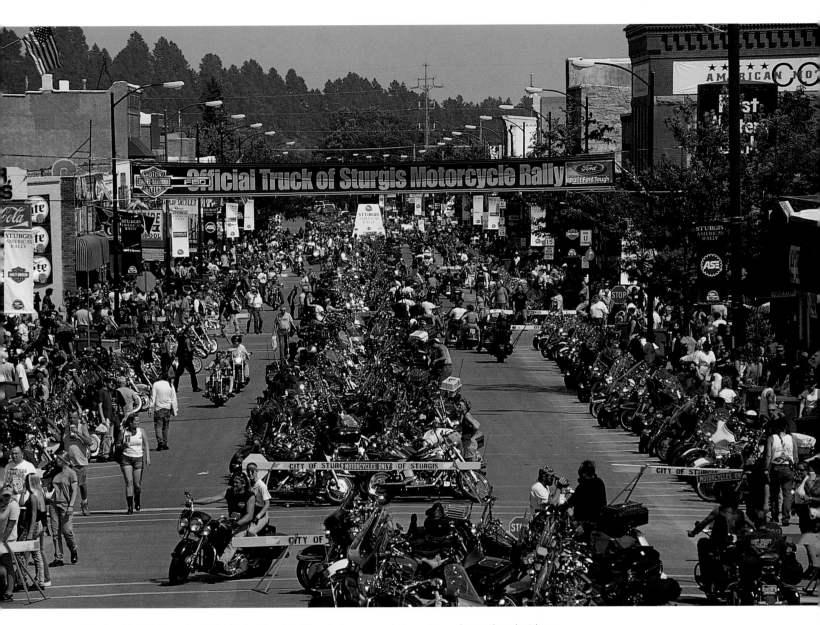

During the Motorcycle Rally, Main Street in Sturgis is open only to motorcycles and pedestrians. The Sturgis Motorcycle Rally, which began in 1938, has become an international event drawing people from all over the world; the Black Hills fills up with half a million bikers or more.

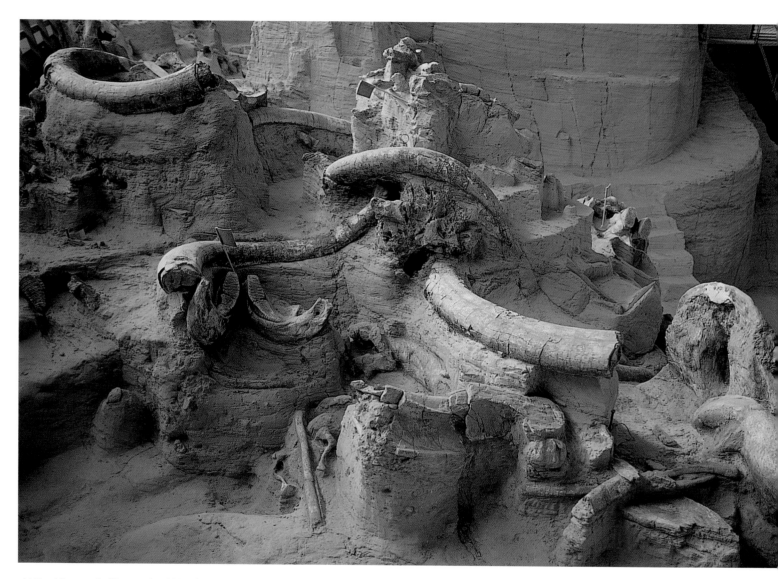

At the Mammoth Site south of Hot Springs are dozens of well-preserved skeletal remains of woolly mammoths from the last ice age. Visitors to the museum can view these fossils exactly as they were found by teams of paleontologists led by Dr. Larry Agenbroad during the mid-1970s and also can view continuing work in progress.

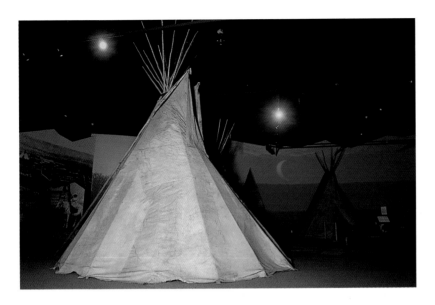

LEFT: This replica of a Plains Indian village is just one of many fascinating exhibits at Rapid City's Journey Museum.

BELOW: Autumn leaves glow against the dark waters of Canyon Lake on the southwest edge of Rapid City as fishermen enjoy a pleasant October day.

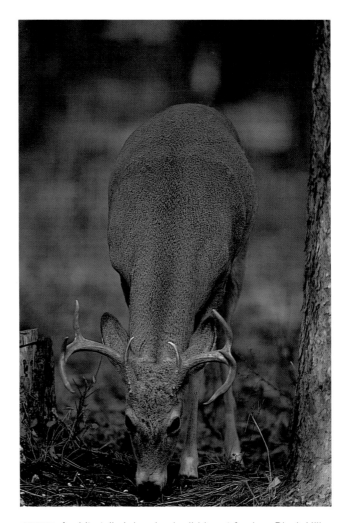

ABOVE: A white-tailed deer buck nibbles at feed on Black Hills National Forest land in the northern hills. Deer are very common in the Black Hills area, even in the towns, so drive with care—especially at dawn and dusk.

LEFT: The sun peeks over the horizon at the dawn of a September day in Custer State Park.

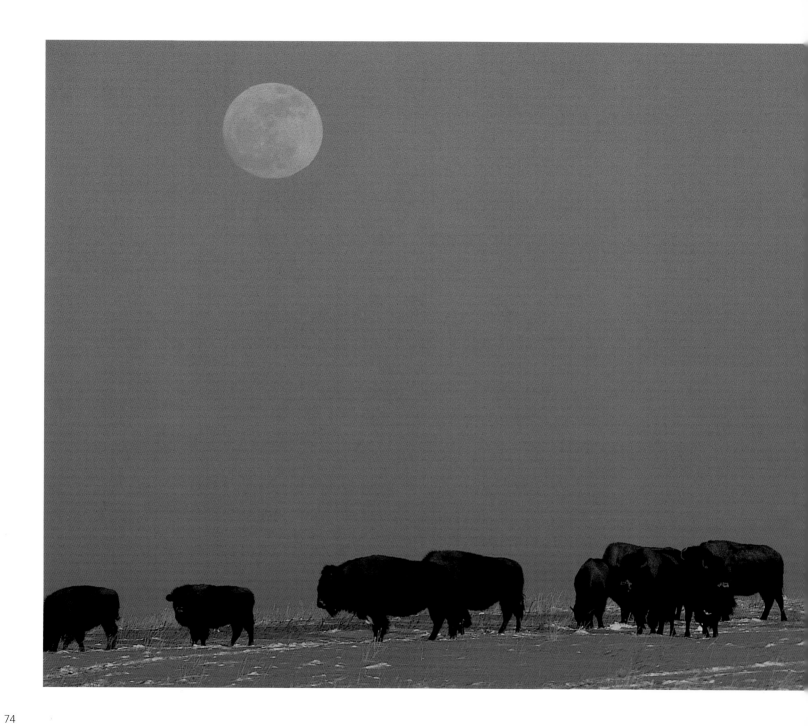

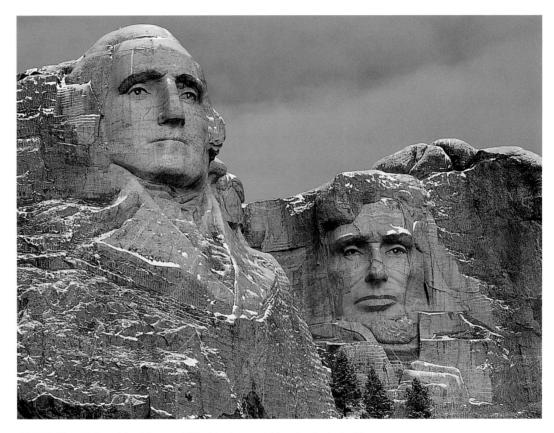

ABOVE: The distinguished faces of Washington and Lincoln dusted with snow, Mount Rushmore National Memorial.

LEFT: A full moon rises in a pink winter sky above a group of grazing bison on Wind Cave National Park land.

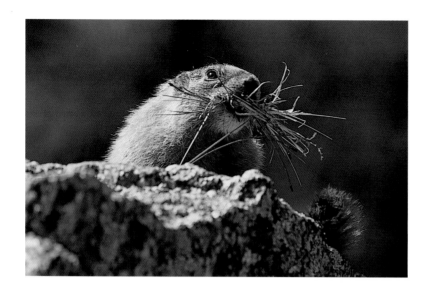

LEFT: A yellow-bellied marmot female gathers grass during early April to build a nest for the young to which she will soon give birth.

BELOW: Prayer cloths and medicine bundles of the Lakota adorn the bare trees of November at the base of Bear Butte in Bear Butte State Park on the northern edge of the Black Hills.

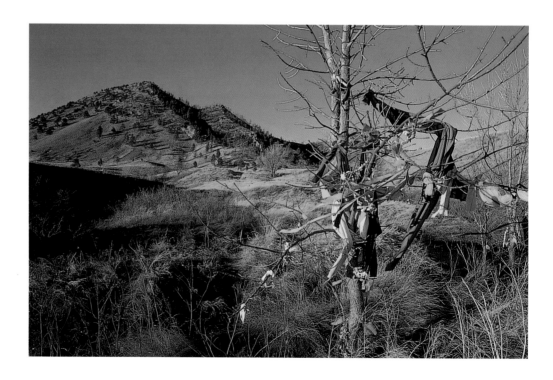

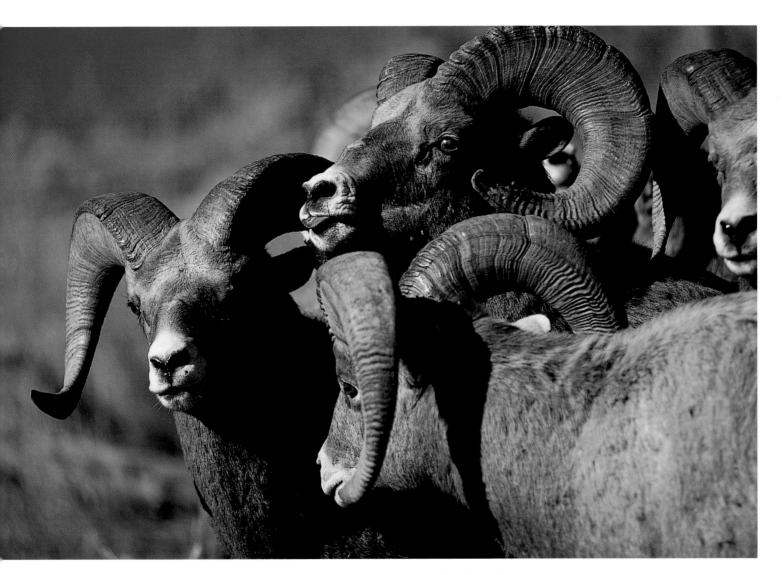

Bighorn sheep rams engage in a rut ritual known as "horning" during late November. Subordinate rams rub their horns against a larger, dominant ram (top center) in a gesture of submission in hopes of getting a turn to mate with some of the ewes. The dominant ram, however, may spurn their efforts—then the battles begin.

A mountain goat yearling kid walks down this ice-covered granite slope during late March in the high country of the central Black Hills.

"Winters is long up here, Pilgrim.... Ya can't fool the mountains, the mountains got its own way." Bearclaw Grizlap, from the film *Jeremiah Johnson.*

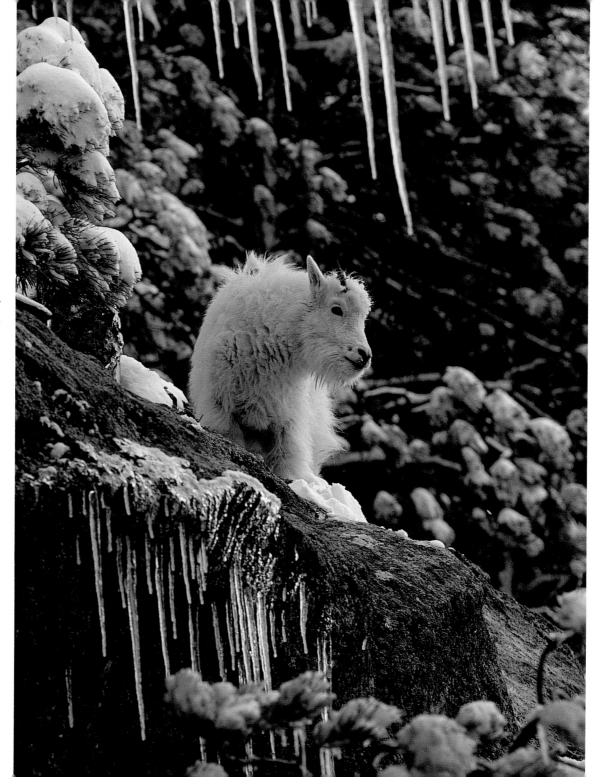

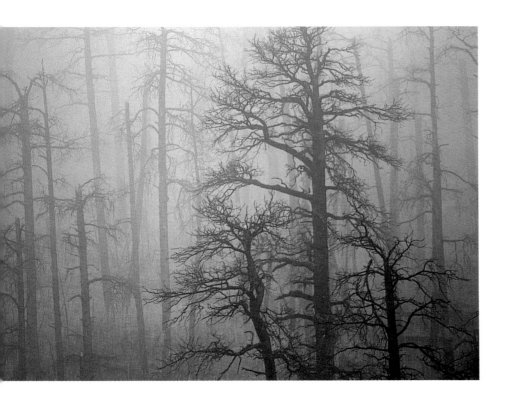

ABOVE: These bare trees of late autumn take on a ghostly appearance on a foggy, rainy morning, hinting of winter's approach.

RIGHT: The grave of the famous frontier Marshall Wild Bill Hickock is located in Deadwood's Mount Moriah Cemetery. Hickock was murdered on August 2, 1876, in Deadwood as he played cards at Saloon No. 10.

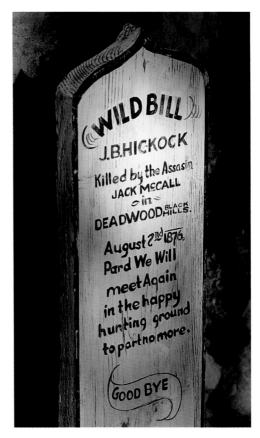

PHOTO BY STEVE MCENROE

As a child, even before he had seen any portion of it, Dick Kettlewell grew to love the American West. Not the mythical west of Zane Grey literature or John Wayne Western films, but the West that he saw in photographs: the stunning landscapes by Ansel Adams and Edward Weston, the *National Geographic* images of places and spaces. Kettlewell's West was the one he read about in the works of Aldo Leopold, Norman Maclean, and John Muir and in the journals of Lewis and Clark.

Kettlewell's photographic roots are in photojournalism, and he has worked for mid- and metro-sized daily newspapers for nearly twenty-five years. During the mid-1990s he took a hiatus from journalism and returned to the Black Hills. His goal is to capture on film the spirit of that American West he first loved from afar.

Currently, Dick produces a regular photographic column called "The Spring Creek Chronicles" for the *Rapid City Journal.*